POSTCARD HISTORY SERIES

Amityville

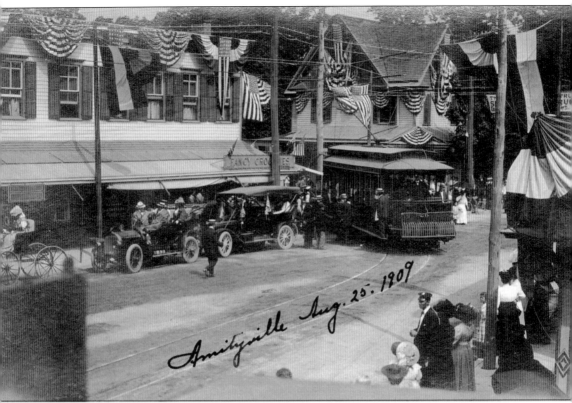

Amityville Aug. 25. 1909

On August 25, 1909, the village of Amityville saw the inauguration of the Cross-Island Trolley, which ran from Huntington to Amityville. It was a historical event, and downtown Amityville, gaily decorated in patriotic buntings, rose to the momentous occasion. The largest crowd ever recorded in the village's history included residents, visitors, and local dignitaries such as future New York governor Alfred E. Smith. In this photograph, the inaugural trolley can be seen rounding the corner at Greene Avenue and turning south onto Broadway on its way to the line's terminus at the foot of Ocean Avenue on the Great South Bay. (From the private collection of Kenneth Lang.)

ON THE FRONT COVER: Since its construction in 1894, the Park North School has been a prominent landmark located in the heart of the village of Amityville. Considered "a true temple of learning" by Joel R. Simon in the December 1977 edition of the Amityville Historical Society's newsletter, the *Dispatch*, this imposing two-and-a-half story brick building provides a fine example of Victorian municipal architecture. (From the private collection of Kenneth Lang.)

ON THE BACK COVER: The Amityville River was long referred to as "the Creek" or, by old-timers, "the Crik." A salt creek of tidal water from the Great South Bay, it has and continues to serve as the home port for a sizeable fleet of watercraft of all sizes and descriptions. One hundred years ago, although commercial vessels far outnumbered pleasure craft, one could still enjoy a peaceful Sunday afternoon rowboat ride along the Crik. (From the collection of the Amityville Historical Society.)

POSTCARD HISTORY SERIES

Amityville

Karen Mormando Klein
Foreword by William T. Lauder

ARCADIA
PUBLISHING

Published by Arcadia Publishing
Charleston, South Carolina

Printed in the United States of America

Library of Congress Control Number: 2011932004

For all general information contact Arcadia Publishing at:
Telephone 843-853-2070
Fax 843-853-0044
E-mail sales@arcadiapublishing.com
For customer service and orders:
Toll-Free 1-888-313-2665

Visit us on the Internet at www.arcadiapublishing.com

To my parents, Stella and Daniel Mormando Jr., who first introduced me to Amityville and continue to inspire me in countless ways

CONTENTS

FOREWORD

This book is a priceless collection of pictorial images reproduced from vintage Amityville postcards. Those cards, preserved and saved from the jaws of oblivion, offer a glimpse into our past, which is not always easy to describe to a technology-oriented society. The overall impact certainly proves the old adage that one picture is worth a thousand words. In fact, these particular cards have been under lock and key in the archives of the historical society and in the caring hands of appreciative private collectors. This is the first time they have been assembled together and put upon public display. A debt of gratitude is certainly owed to the author for her time-consuming efforts and treatment of the treasure.

These various, now precious cards were randomly issued over an extended period. Our author has, with great care and feeling, gathered them into the many separate aspects of past and present daily community life. They remind and show us the gradual and imperceptible changes that have morphed the community into the delightful suburban enclave we live in today.

Fortunately, postcard collecting was a prevalent hobby prior to the beginning of the last century and lasted until about 1914. Almost every family had its album, and the practice was given the name *deltiology* in about 1945. Actually, collecting and saving pictorial art and images began with the cavemen writing on their walls and progressed from there. Each society and generation also tweaked image-collecting to its own pleasure. Egyptians expressed theirs in pyramid tombs while Greeks and Romans did the same in their marble statues, the Renaissance had religious art, and then came worldly and portraiture art down to the present. Our postal art was spawned by man's desire to communicate in a quick, cheap, colorful, and interesting manner. Postcards are said to have been originated by Hungarian postal authorities in about 1860, and the concept quickly spread worldwide. In the middle of the 19th century, before the prevalence of the telephone, the cheapest and quickest way to communicate with one's family, friends, and business associates was by way of the postcard.

The concept of the postal card in the United States was privately conceived in 1861 by John P. Chariton. He is said to have obtained a copyright and transferred it to a Mr. Lipman who privately marketed them until 1873. At that time, a postcard cost the letter rate of 2¢ to mail. In 1873, the government issued postcards with prestamped 1¢ postage. In 1898, the postage for privately issued cards was also reduced to 1¢. US postcards have a front and back. Originally, by law, the front side was for pictures and/or writing, causing writing to be seen across many pictures. The entire back side of those cards was reserved exclusively for the address. In 1907, the law was changed, and the back was directed to be divided down the middle, with the right side dedicated to the address and the left side for a message—thus sparing us the former frequent defacing of the picture on the front. In about 1890, privately printed multicolored picture cards were introduced in Europe. Thereafter, the vast majority of such cards were printed there and particularly in Germany. Those cards were superior in color and clarity and, therefore, preferred to those privately printed here. World War I caused the destruction of the European printing plants, and printing techniques improved here after the war, such that domestic cards became acceptable. Multicolored souvenir cards are still quite popular, and every kind of entrepreneur uses a variation for advertising purposes.

You might say, through the courtesy of the various past national postal authorities and private entrepreneurs, we now have a treasure trove of old pictorial postcards, once necessary and useful and now nostalgic, informative, and collectible. This engaging book will surely provide the reader with a very enjoyable and pleasant trip through our picturesque past.

—William T. Lauder, Amityville village historian

ACKNOWLEDGMENTS

The writing of this book could not have been accomplished without the guidance and support of several people. First and foremost is my dear friend Patricia Cahaney, president of the Amityville Historical Society, whose original suggestion and frequent encouragement along the way resulted in the book that you are now holding. Although there are many whose knowledge of Amityville village history far surpasses my own, there are a few whose research, writing, and enthusiasm for local history has served as my inspiration. Specifically, I wish to thank Seth Purdy Jr., curator of the Lauder Museum in Amityville, and William T. Lauder, Amityville village historian, each of whom possesses a sweeping knowledge of local history that is at once both effortless and deeply fascinating. Together, their many contributions toward preserving our community's rich history are truly invaluable. This book, however, would not have been possible without the encouragement and generosity of Kenneth Lang, a private collector and Amityville historian, whose lifelong appreciation of vintage postcards has resulted in an unparalleled collection. It is this well-tended collection, depicting Amityville at its finest, that essentially forms the basis of this book. Without his years of dedication, there would be no book. All other postcards were graciously provided by the Amityville Historical Society.

I also wish to thank my acquisitions editor at Arcadia Publishing, Abby Henry, for her continual expert guidance. Thanks also goes to Mary Cascone, historical archivist for the Town of Babylon and her intern, Kelly Filippone, for accomplishing the arduous task of digitally scanning all the postcards. Finally, to my husband, Jack, and children, Brett, Mia, and Jolie, thank you for your patience and support through the many missed meals and forgotten errands during the seemingly endless writing of this book.

One

ALONG THE BEATEN PATH

BROADWAY AND EARLY

MOM-AND-POP MERCHANTS

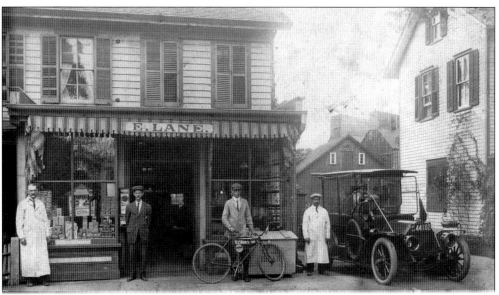

E. Lane's Grocery was located on the west side of Broadway, just south of the railroad station. This photograph, taken in the fall of 1915, depicts proprietor E. Lane (second from left) with three employees. That same year, an employee named Woodford sent this postcard to his "Aunt Lizzie" asking if she could recognize him. Years later, the building became the Sunrise Market, and is a Laundromat today. Note both the automobile and bicycle used for making deliveries, a common service at the time.

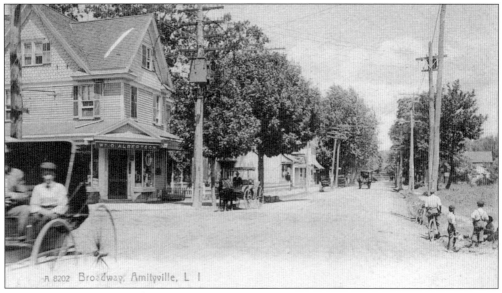

A 8202 Broadway, Amityville, L I

Located on the west side of Broadway at the northwest corner of Railroad Avenue, today Greene Avenue, was Albertson's Drug Store. Founded by William G. Albertson in 1888, it was best known as the first building in Amityville with a telephone. The phone number was, logically, Amityville 1. It is seen on the left in this photograph taken in about 1898. Previously, this building was occupied by the Robbins Brothers' butcher shop.

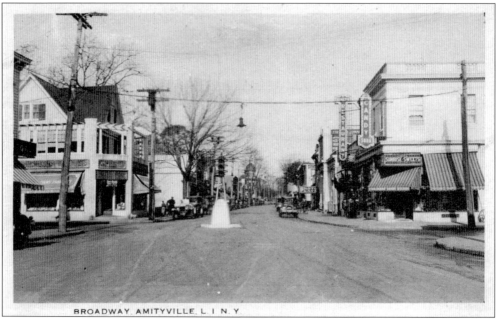

BROADWAY, AMITYVILLE, L. I. N. Y.

A view of the same location nearly 30 years later shows a blinking traffic column in the middle of the intersection. In 1943, Albertson's employee F. Burton Phannemiller purchased the business and changed the name. Phannemiller's popularity grew after the soda fountain in the back of the shop was restored after many years of absence. Phannemiller's was also known for its mysterious and colorful apothecary jars in the window. The pharmacy closed in July 1994. Today, a popular restaurant, Vittorio's, occupies the space.

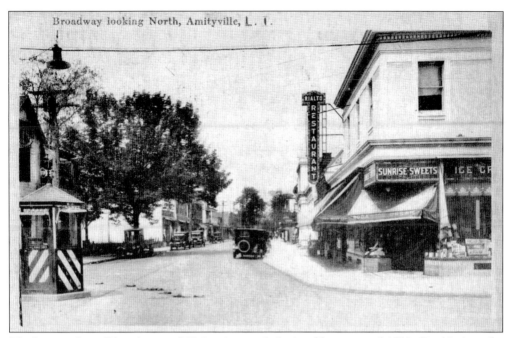

The intersection of Broadway and Union Avenue is depicted here around 1930s. By this time, the blinking traffic signal had been replaced with a fully manned police kiosk. Sunrise Sweets and Ice Cream, owned by the locally famous Troumbas brothers, is on the northeast corner of Broadway and Union Avenue next to the Rialto Restaurant.

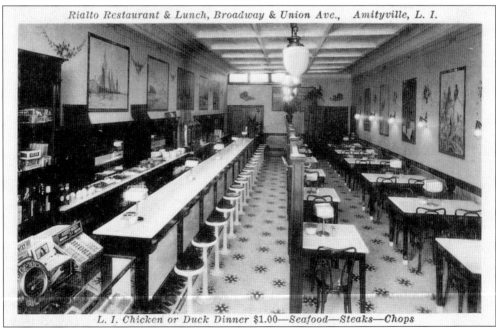

The Rialto Restaurant and Lunch was located on Broadway just north of Union Avenue in the heart of the village. With a large vertical marquee, it advertised seafood, steaks, and chops and offered daily specials such as chicken or Long Island duck dinners for $1. Note the fancy decor including framed artwork, cheerful floor tiles, and hand-stenciled walls—all popular at the time.

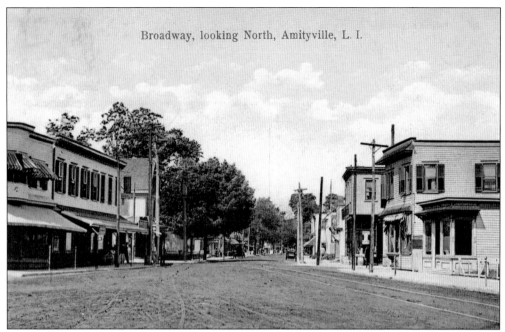

Broadway, looking North, Amityville, L. I.

Located at the southwest corner of Greene Avenue and Broadway was Maul's Fancy Groceries. Owned and operated by Adolph and Otillie Maul, this popular old-fashioned grocery store occupied the wooden, canopied building seen in the above photograph on the left and on the right in the photograph below. Early each morning, Otillie Maul could be seen rolling the large barrels that contained provisions such as flour and sugar to the sidewalk. Many days, Adolph Maul would return from New York City on the Long Island Rail Road, carrying lengths of bologna and sausage that he had personally selected for his shop. The store was later sold to Thomas Roulston and operated as a chain under the name Roulston's. After the building was torn down, the First National Bank was erected on this site in 1927.

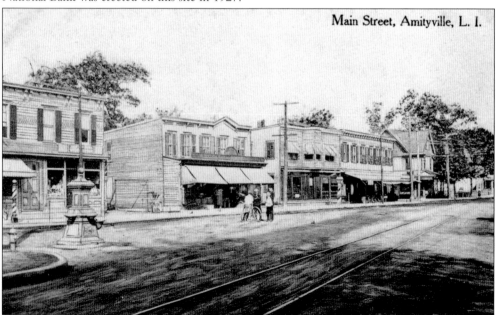

Main Street, Amityville, L. I.

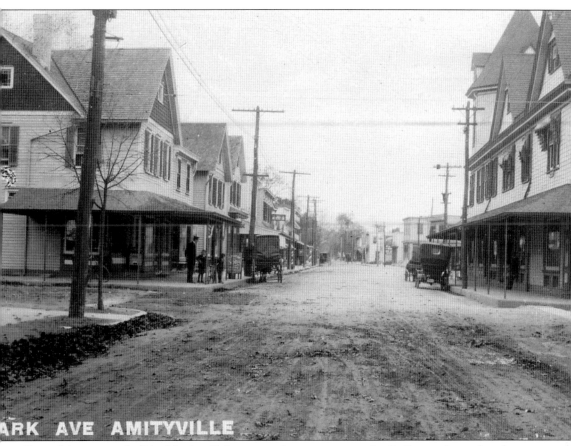

ARK AVE AMITYVILLE

One of the most colorful of Amityville's mom-and-pop stores was Losi's Corner, located at the northwest corner of Park Avenue and Ireland Place. Originally built as a harness and saddle shop in 1899, the two-and-a-half story structure boasted the first paved sidewalk and was first to install electric lights in the area. Converted into a dry goods shop by Anton Figari, the store was purchased upon his death by his partner Louis Losi in 1908. Losi was especially fond of children, and his store was known for its selection of penny candies and school supplies. It was also famous for its choice fruit baskets and, in the 1930s, for Edith Fowler's delicious clam pies. For over 60 years, patrons from as far as Brooklyn and many celebrities of the day, such as Will Rogers and Fred Stone, traveled to Amityville to sample the many specialties found at Losi's Corner. This building remains nearly unchanged today.

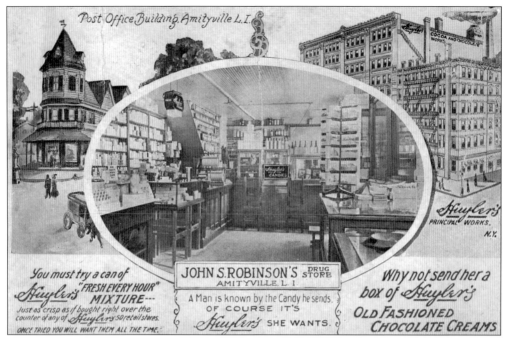

On Broadway, Robinson's Drug Store was located nearly halfway between Losi's Corner and Maul's Groceries. Established in 1880 by John Robinson, it was later operated by his wife after Robinson's untimely death during World War I. Robinson's used advertising such as this postcard depicting local sites such as the Triangle Building and Huyler's Cocoa and Chocolate Works. Mrs. Robinson also conducted private classes for schoolchildren on the second floor above the store.

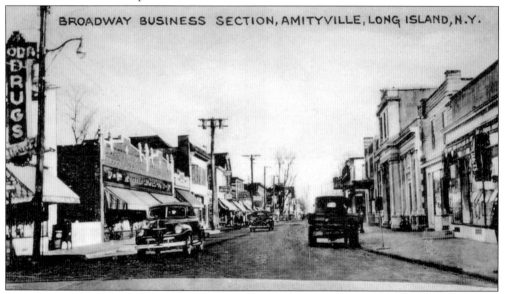

Looking north on Broadway at Greene Avenue, this c. 1940s photograph was taken prior to the road-widening and depicts the heart of the downtown business district. On the west side of the street, Phannemiller's, formerly Albertson's Drugs, is visible, as is the McLellan's 5 & 10 Cent Store. On the east side, most notable is the original First National Bank building and in the distance, the Amityville Theatre marquee is visible. Note the patrolman walking his daily beat.

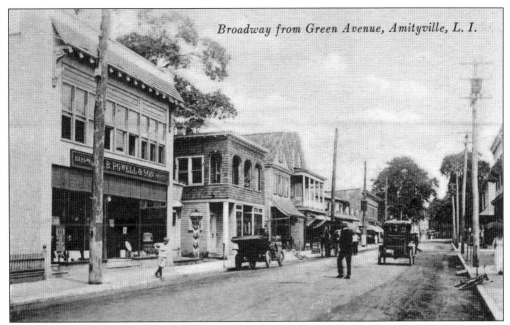

Broadway from Green Avenue, Amityville, L. I.

Just further north, the F.B. Powell & Son Hardware and Paint shop is seen on the left. This building, still in existence today, was originally used as the town hall for the town of Babylon, which was established in 1872. In later years, the hardware business was taken over by Frederick J. Nienburg and Sons and later sold to George W. Cort.

Broadway, Amityville, L. I.

This early-1900s photograph of Broadway, taken just south of Oak Street, depicts several buildings that no longer exist. Necessary for the 1950s westward extension of Oak Street was the demolition of the two shops shown here on the left. These included the old Quick's news depot, which later became Christoffer's Stationery Store, and a curtain shop. Christoffer's relocated to the newly created corner building just south and has enjoyed a long and prosperous village life.

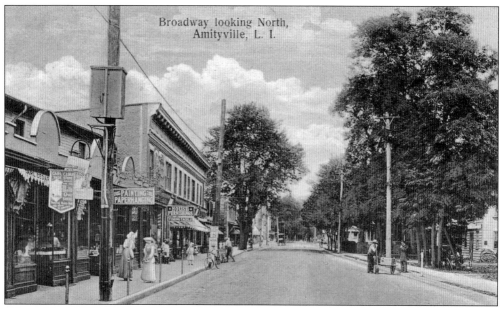

Broadway looking North,
Amityville, L. I.

In the area known as the Plympton Block, this busy turn-of-the-century street scene shows two formally attired women, discussing perhaps their recent decorating choices on the sidewalk beside the home furnishings, paint, and paper-hanging shop. A little girl waits by the curb, while across the street, a farmer with his wagon stops to chat with the local patrolman. Note the many hitching posts.

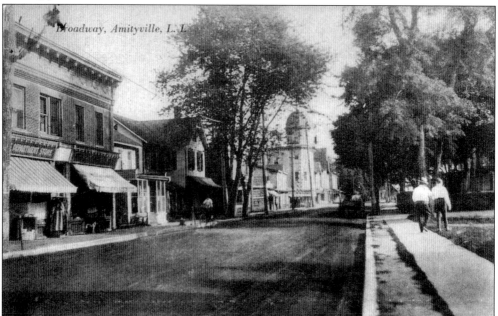

Broadway, Amityville, L. I.

In a view continuing north on Upper Broadway, this photograph shows the commercial businesses along the west side extending to the railroad. At left is the Plympton Block building, virtually unchanged today. Although this structure has served as home to many different commercial businesses, a department store occupies the front space in this image. Across the street, two men are seen walking towards Wardle's Hotel.

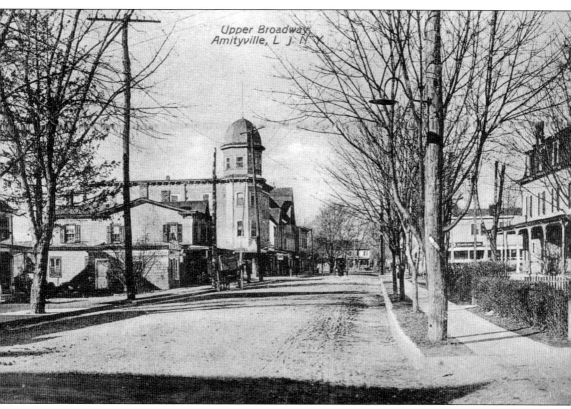

Named after its owner, the domed structure beyond the railroad gate is the Velsor Building. Occupied by the Charles Wood Lumber Company, this elegant three-story edifice was located at, logically, Lumber Place, which is today named Sterling Place. In later years, it became the Nassau-Suffolk Lumber Company. The original building, crowned with a magnificent Victorian turret, was unfortunately built of longleaf yellow pine, known for its ability to burn fiercely. In 1955, during one of Amityville's worst fires, the landmark structure succumbed in a blaze fought with one-and-one-half million gallons of water and with heat so intense that it melted the tires of fire engines. Charles Wood became the first president, or mayor, of Amityville. Today, the site is occupied by a convenience store.

AT AMITYVILLE L I N Y.

This c. 1920s photograph was taken just east of the Triangle Building and shows every building on the east side of Broadway between St. Mary's Church and Union Avenue lost as a result of the road-widening in 1959. Further north, old Broadway was originally built as a 16.5-foot-wide (one rod), two-lane cement thoroughfare. This section was widened in 1939.

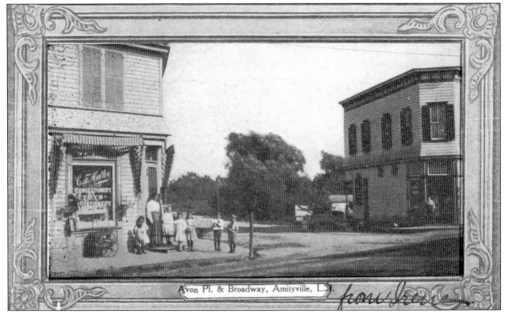

Avon Pl. & Broadway, Amityville, L.I.

Muller's Confectionery and Lauder's Bakery sat across from each other on the north and south corners, respectively, of Avon Place at Broadway. Lauder's Bakery, established in 1894 by Thomas Lauder, grandfather of village historian William T. Lauder, was located in the Skinner Building, named after its owner, William Skinner. Muller's Confectionery was also a stationery and toy store. A testament to its popularity, this image shows no less than six children posing at its threshold.

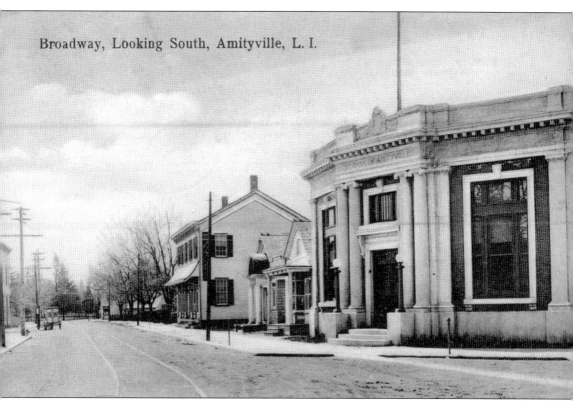

Broadway, Looking South, Amityville, L. I.

This sweeping photograph of the corner of Broadway at Ireland Place shows, from the right, the original Bank of Amityville (built in 1909), James Lauder's butcher shop, Amityville's first library building, and the Frank Smith Dry Goods Store. The dry goods store was built in 1872 and first served as the village's schoolhouse. Originally located around the corner on Park Avenue, it was moved to its present location in 1892 to make way for a far larger school building. After the dry goods store closed, the building served as a temporary home for the Simpson Methodist Church, then as the Amity Battery and Ignition Store, and is now an office building. Across Broadway at the corner of Avon Place, Lauder's Bakery and wagon are seen at left.

On the northeast corner of Broadway and South Country Road, now called Merrick Road, the Homan and Van Tassel Building is seen in its original grandeur in this c. 1905 image. Built in 1892 by Charles F. Hart, the elegant three-story Victorian structure housed Amityville's first freight elevator. Homan and Van Tassel's, as it was called, was considered ahead of its time and operated much like a modern-day department store, providing a vast variety of merchandise under one roof. Later, the ground-floor space was converted to an automobile showroom. Due to structural defects, the original building was demolished in 1929.

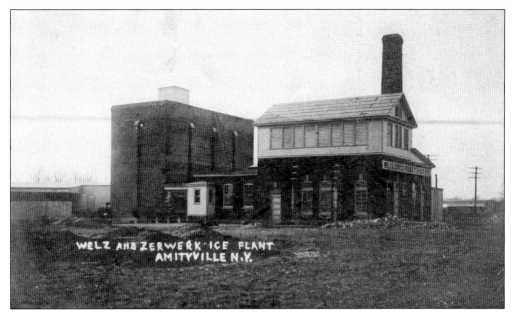

During the early 1900s, the Welz & Zerwerk Ice Plant and Brewery was located just west of the Amityville train depot at the southeast corner of County Line Road. From the ice plant, water flowed through a long pipe along the east side of County Line Road, emptying into the headwater of the Narrasketuck River, then located opposite Franklin Street south of Merrick Road. Later, the plant became the Knickerbocker Ice Company.

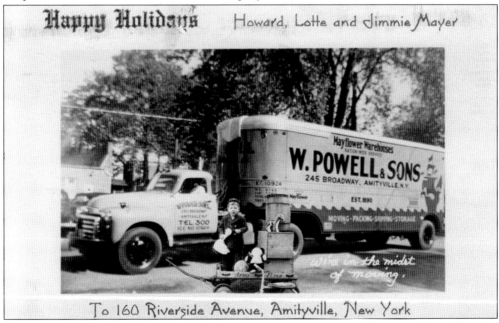

Established in 1890 and originally providing livery service, W. Powell & Sons, located at 245 Broadway, became well-known movers, packers, shippers, and storage providers. Their phone number was Amityville 300. This holiday greeting card depicts a young boy with his Christmas loot piled atop an Aero Flyer wagon and is inscribed with the words, "We're always in the midst of moving." Today, the site is occupied by a bank.

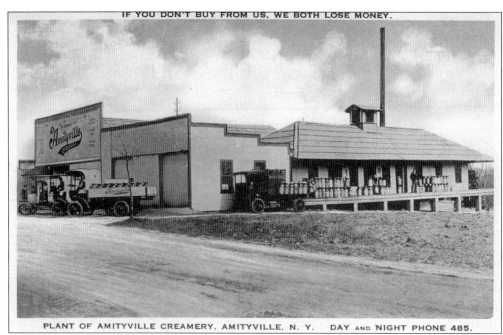

PLANT OF AMITYVILLE CREAMERY, AMITYVILLE, N. Y. DAY AND NIGHT PHONE 485.

The Amityville Creamery was located on Wellington Place and Railroad Avenue near Hartmann's Lake. One of Amityville's largest commercial enterprises of the time, its motto was "If You Don't Buy From Us, We Both Lose Money." Later, the creamery merged with the Evan's Dairy of Rockville Centre, becoming the Amityville-Evans Dairy. During the 1950s, Hartmann's Lake was renamed Peterkin Park. A condominium complex occupies the site today.

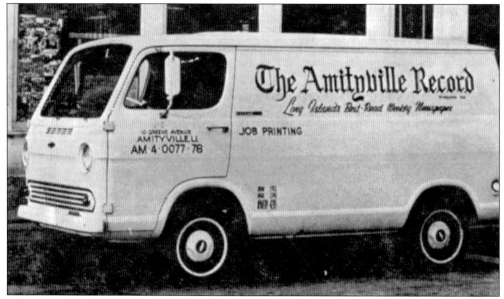

The *Amityville Record*, founded in 1904 by Charles Delano, was originally located east of the first fire headquarters on Greene Avenue. After new fire headquarters were built, the Record offices moved into the original firehouse, moving it further back on the same property. The Delano family continued the popular newspaper's publication until 1972. Today, it continues to be published weekly under new owners.

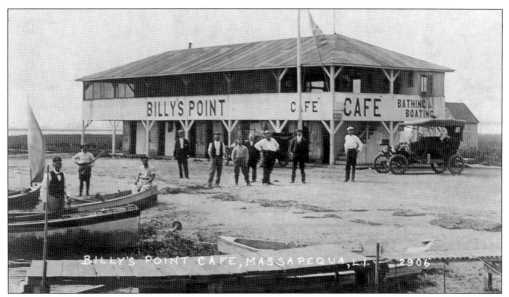

Located on Great South Bay at the western boundary of Amityville, the site of Billy's Point Café is today considered to be a part of East Massapequa. The original occupant, Billy's Point Café, offered boat rentals, a bathhouse, and popular café. Recently, this waterfront location has seen, in turn, Ciro's on the Bay, the Goal Post Restaurant, and the Wine Gallery. Today, the site is occupied by several modern homes.

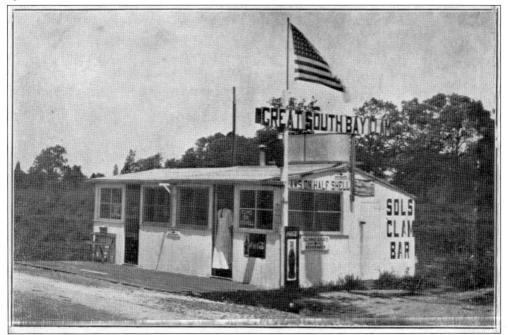

The historic building that housed Sol's Clam Bar was first used as the tollhouse and stagecoach stop operated by Carman's Mill. Located on South Country Road (now Merrick Road), at the western entrance to Amityville, the old tollhouse was later moved north to Carman's Mill Road and became Sol's Clam Bar. Seen here in an undated photograph, Sol's became known for its Great South Bay clams and other seafood delicacies.

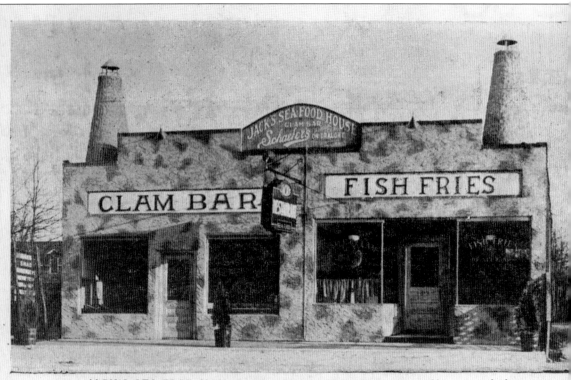

JACK'S SEA FOOD HOUSE, AMITYVILLE, END OF SUNRISE HIGHWAY, L. I.

Nearly one mile north of the bay, Jack's Seafood House and Clam Bar was located on Hallet Street, known today as Old Sunrise Highway, in what was then considered West Amityville. Famous for his fried-fish dinners, Jack clearly had an eye for detail, as noted by the café curtains and potted topiaries on the sidewalk in this undated image. The original building, unrecognizable today, still stands in the same location.

Two

An Iconic Landmark
The Triangle Building

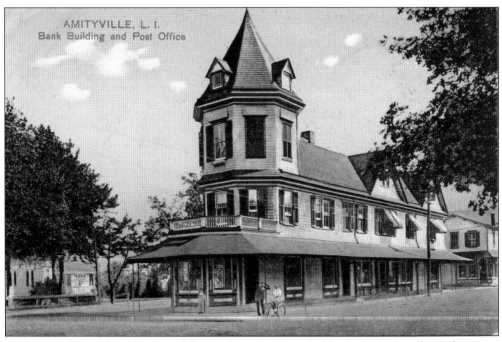

AMITYVILLE, L. I.
Bank Building and Post Office

Without question, the Triangle Building is the most recognizable site in Amityville. Built upon a triangular plot of land that intersects Broadway, Park Avenue, and Ireland Place, this area was once a picnic grove. The iconic three-story, frame structure crowned with a Victorian turret was built by Erastus Ketcham in 1892. Sadly, Ketcham fell to his death while shingling the steep roof during construction of this building, leaving behind a widow, Hulda, and 10 children.

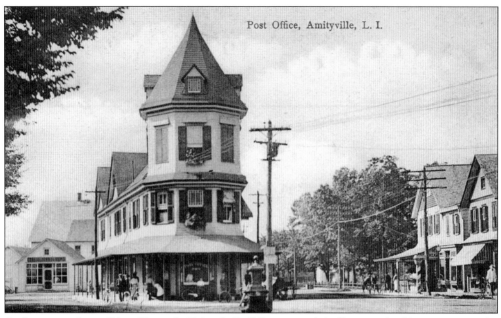

As the centerpiece of the village, the Triangle Building was originally conceived in response to the growing need for community space. The village's first official office building, its original tenants included the post office, village hall, and the Bank of Amityville. Amityville's first postmaster was Solomon Ketcham, who was succeeded by Frederick B. Powell. Other early tenants included Amityville Water Works Company and the Electric Power & Light Company.

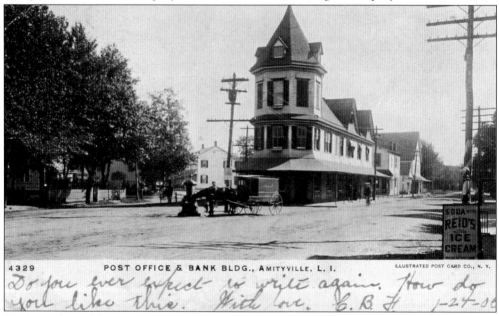

4329 POST OFFICE & BANK BLDG., AMITYVILLE, L. I. ILLUSTRATED POST CARD CO., N. Y.

The Triangle Building was graced with an ornate water trough, shown here, where horses slaked thirst caused by the dust of early unpaved roads. Shortly after the original construction, a canopy was added on all sides to shelter the sidewalk. A common site during the 1930s and 1940s was to see schoolchildren playing beneath the canopy during recess from the nearby Park North building. Note the sidewalk sign advertising Reid's Ice Cream and Soda.

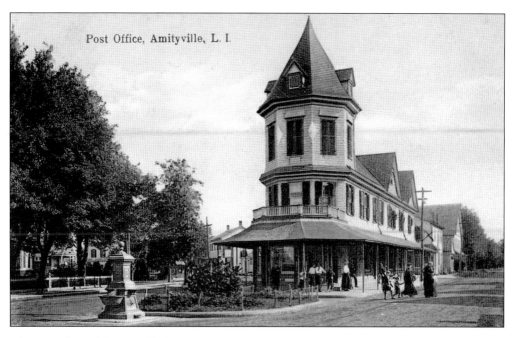

Post Office, Amityville, L. I.

The Triangle Building quickly became a community gathering place for local townspeople, as well as farmers who came each week from the outlying areas to the north and east to pick up their mail and newspapers. At various times, the Triangle Building provided a home for the Christian Science Reading Room, the newsroom of the *Long Island Sun*, the law offices of village president Samuel Hildreth and Frank T. Wells, the headquarters of the Waukewan Canoe Club, and the village courtroom, which occupied the third floor. The distinction of longest tenant belongs to the Ketcham & Colyer Insurance Agency, which was founded in 1890 and remained in the building through the second half of the 20th century.

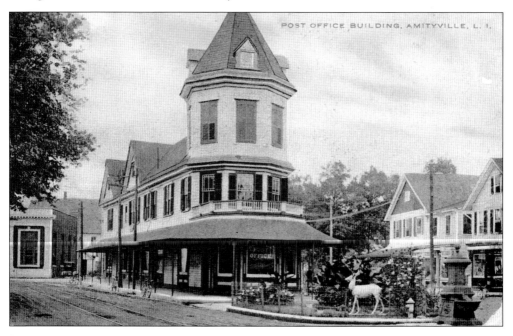

POST OFFICE BUILDING, AMITYVILLE, L. I.

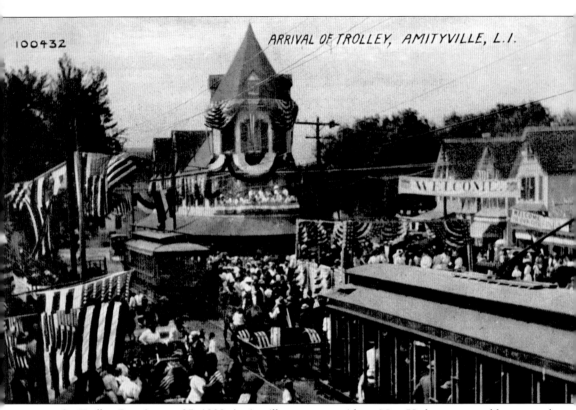

ARRIVAL OF TROLLEY, AMITYVILLE, L.I.

WELCOME

On Trolley Day, August 25, 1909, Amityville summer resident, New York state assemblyman, and future New York governor Alfred E. Smith presided over the inauguration of the Huntington-Amityville Cross-Island Trolley. The christening of the trolley, planned by the Long Island Rail Road, provided a tremendous cause for celebration for the growing village. Early automobiles and fancy surreys rented from the local livery stables lined Broadway and overflowed with revelers who came out to witness the event. This photograph depicts the inaugural trolleys proceeding south on Broadway past the Triangle Building to the station terminus at the foot of Ocean Avenue on Great South Bay.

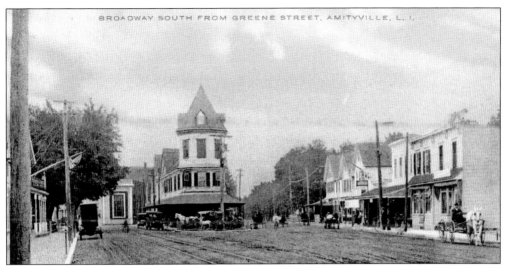

Described by Seth Purdy Jr. in his book *A Backwards Glance* as "presiding over the heart of town with the dignity of a stately dowager," the Triangle Building has survived fire, structural improvements, and the threat of the widening of Broadway in 1959. For many villagers, it is most commonly recognized as the center of celebrations, parades, political rallies, and the popular Liberty bond drives during World War I.

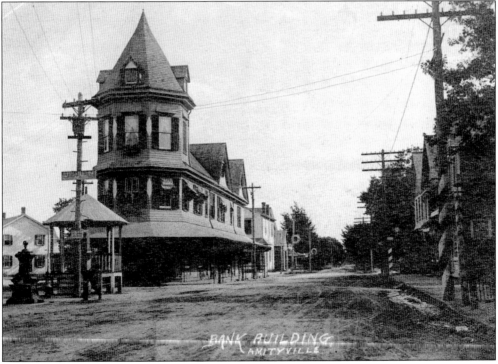

In this photograph taken shortly after initial construction, the original bandstand, or belvedere as it was then called, can be seen directly in front of the Triangle Building. Musical concerts and other performances were frequently staged here. This unadorned bandstand, eventually removed due to deterioration, was replaced much later by a new, more elaborate gazebo constructed slightly north of the original.

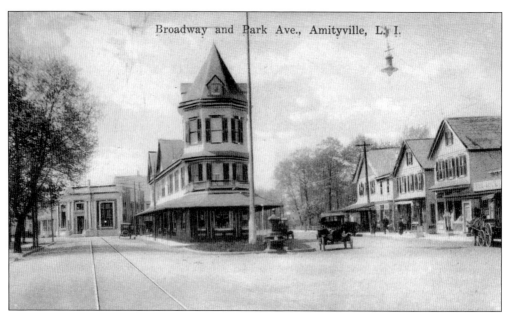

Broadway and Park Ave., Amityville, L. I.

Other notable Triangle visitors have included Pres. Theodore Roosevelt, New York City Parks and Recreation commissioner and Long Island planner Robert Moses, and future president Richard Nixon, who together with Gov. Nelson Rockefeller paused here briefly during the 1968 presidential campaign. More recently, Amityville celebrated the homecoming of one of its native sons, astronaut Kevin Kregel, during the late 1990s.

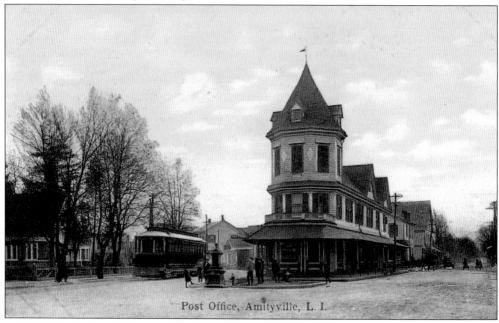

Post Office, Amityville, L. I.

In November 1918, a spontaneous parade that celebrated the end of World War I was led by Max Haymowitz, proprietor of the 3, 9 and 19 Cents Store on Broadway. Astride a donkey never before seen in the village, he led schoolchildren and adults alike in a jubilant procession around Broadway, Merrick Road, and Park Avenue. Note the Cross-Island Trolley, which operated between 1909 and 1919, as it passes in front of St. Mary's Church.

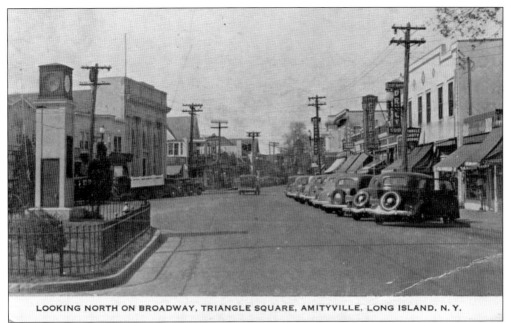

LOOKING NORTH ON BROADWAY, TRIANGLE SQUARE, AMITYVILLE, LONG ISLAND, N.Y.

As a suitable memorial for local World War I servicemen who had lost their lives during the war, plans were undertaken for a memorial clock to be placed in the center of town adjacent to the Triangle Building. J. Leland Wells was appointed to supervise the installation. The 10-foot-tall granite monument was surmounted with a four-faced bronze clock that was to be wound automatically by electric motor. On Thanksgiving Day 1920, the memorial clock was unveiled by Annie Watson, whose son Robert Edwin Watson was killed in action in 1918. Presently, the clock is accurate exactly twice daily. These photographs, taken decades apart, depict the memorial clock, as well as the many changes in the surrounding area, particularly the east side of Broadway.

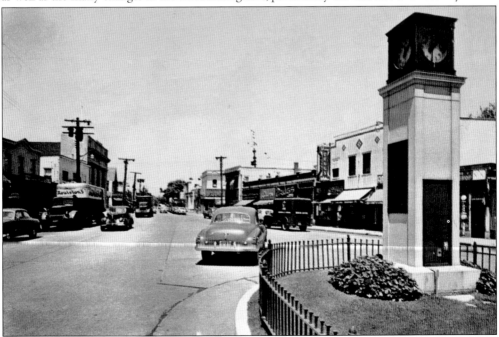

In this c. 1980 image, the Triangle Building presides without its Victorian turret. In February 1949, it was removed by the building's owner after it had become dangerous and in need of extensive repair. During the 1990s, an elaborate effort was sponsored by the Main Street Alliance and Amityville Centennial Committee to restore the original turret. On July 3, 1995, a new modern turret, designed after the original, was unveiled and dedicated before a cheering crowd.

During the 1980s, a village tradition began in the area surrounding the Triangle Building. After closing the street to traffic, an annual Christmas tree lighting ceremony takes place, which includes a visit from Santa Claus. The original 25-foot-tall spruce shown in this post-1995 photograph surrendered to a ferocious February 2010 rainstorm. Shortly thereafter, the tree was replaced by an 18-foot-tall blue spruce generously donated by the Amityville Kiwanis Club.

Three

THE WATERFRONT

BEACHES, FERRIES, PONDS, AND "THE CRIK"

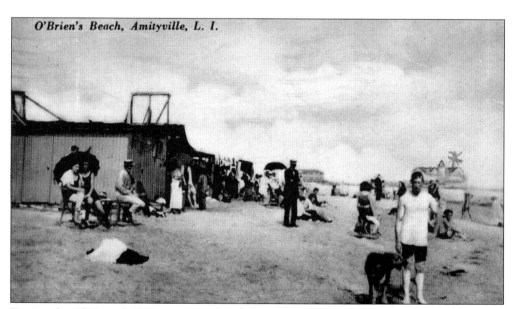

O'Brien's Beach, Amityville, L. I.

During the 1910s and 1920s, a private beach known as O'Brien's Beach, or "Denny's Ocean," operated on Great South Bay. Considered the first official beach in Amityville, it was owned and operated by Dennis O'Brien. Located on the east side of Unqua Place at the foot of Ocean Avenue, it sat opposite the two grand hotels, the Hathaway Inn and the Hotel New Point, seen here in the distance.

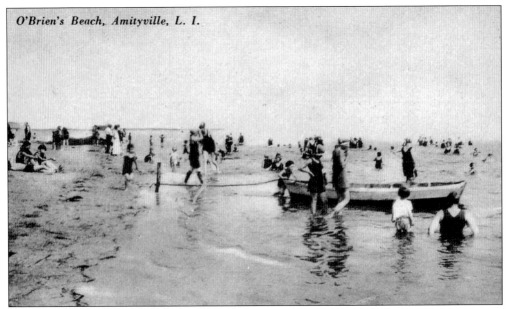

O'Brien's Beach, Amityville, L. I.

A seasonal pass to O'Brien's Beach was available for purchase, or a small fee was charged for the daily use of a locker and the bathhouse. A pavilion provided basic amenities such as beach chairs, refreshments, and shelter from the sweltering sun. As it was considered unfashionable to sport a suntan in those days, umbrellas were a popular sight.

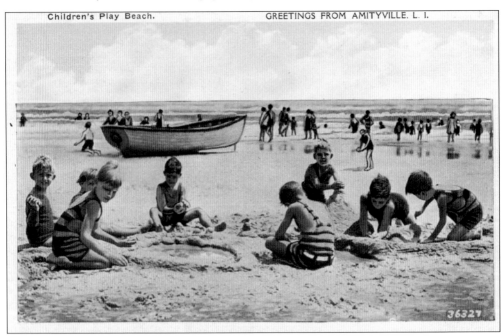

Children's Play Beach. GREETINGS FROM AMITYVILLE. L. I.

In 1939, following a petition with 285 signatures in favor of the creation of a municipal beach, village officials agreed to buy 17.5 acres at the foot of South Bayview Avenue from the estate of Alfred G. Vanderbilt. On Saturday, June 8, 1940, Amityville Beach was officially opened amidst a grand parade and village-wide celebration. The first weekend's attendance exceeded 2,300 bathers and 1,250 cars in the parking field.

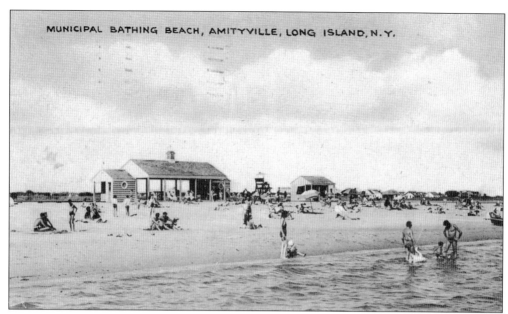

Beach regulations limiting the use to Amityville residents, property owners, tenants, and hotel guests were adopted. Proper bathing attire was required, and of course, no nude bathing was permitted, among other things. The rustic beach was continually developed. Marshy acreage was filled in, courtesy of the Amityville Rotary Club, and playground equipment was furnished by the Kiwanis Club, who also helped with the construction of a pavilion, which still stands today.

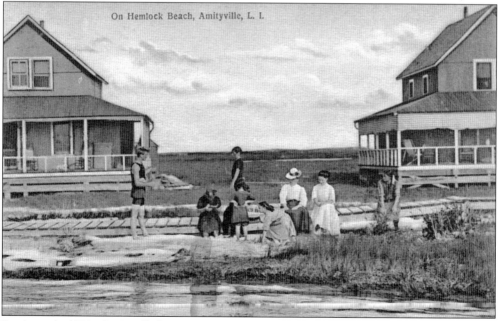

On Hemlock Beach, Amityville, L. I.

By the early 1900s, Amityville became a popular vacation spot to escape from the oppressive heat of the city. A customary summer outing often included an excursion by ferry to the white sands of the outer barrier beaches. During this time period, there were no less than three scheduled ferry boats that sailed across Great South Bay from various docks along Amityville Creek.

35

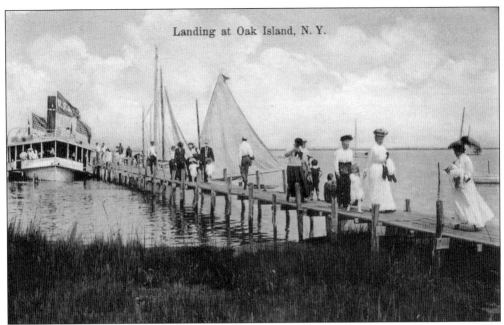

Landing at Oak Island, N.Y.

The three busy ferryboats that operated from Amityville were the *Adele*, the *Atlantic*, and the *Columbia*. These ferries started out as side-wheelers but were eventually reconfigured and fitted with stern propellers. The popular beaches of the day were Oak Island Beach, Hemlock Beach, Gilgo Beach, and High Hill Beach. All but High Hill Beach remain today.

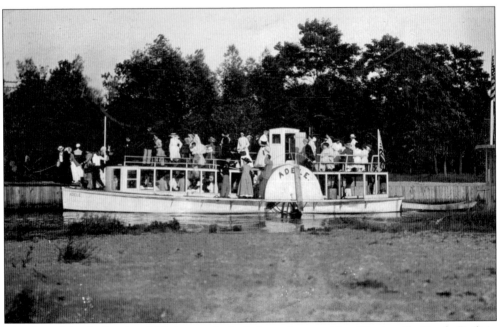

The first of the ferries, the *Adele*, is seen docked along the east side of Amityville Creek. Built in 1903, the *Adele* was operated by Charles Sprague, who named the vessel after his wife. At 48 feet, the cross-planked flatboat was said to have vibrated so much that it made the trip to the beach most uncomfortable.

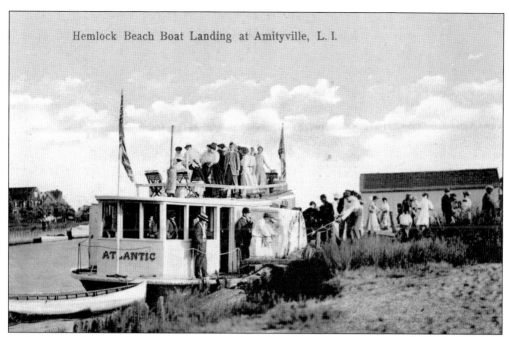

Hemlock Beach Boat Landing at Amityville, L. I.

In the above photograph, passengers are seen boarding the *Atlantic* at the Amityville Creek dock. The grandest of the fleet, the *Atlantic* was built, owned, and operated by Frank Wicks in 1905. Known to one and all as "Captain Frank," he lived on Ocean Avenue, where his boatyard was located just north of Coles Avenue. He leased dock space, however, further to the north (seen here), on the west side of the creek at Merrick Road. After completion of the 65-foot-long craft, which held 150 passengers and was designed specifically for ferry service, Captain Frank and his sons Will, Ollie, and Clifford put her into service on a regular basis. In the below photograph, passengers are seen making the return trip to Amityville from the landing at Gilgo Beach.

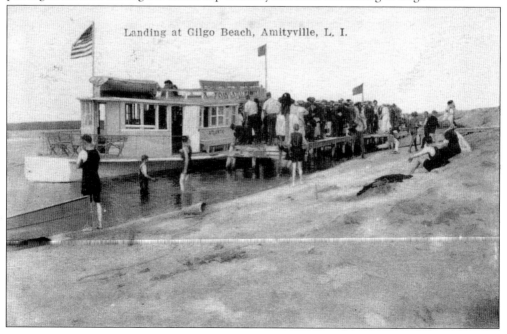

Landing at Gilgo Beach, Amityville, L. I.

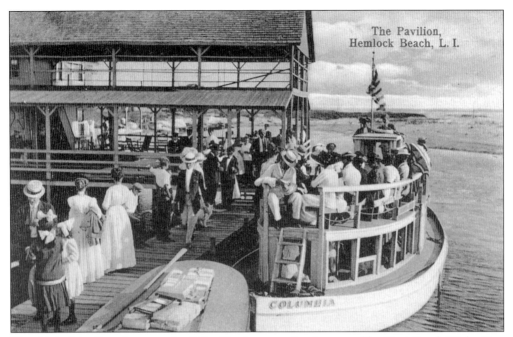

The Pavilion, Hemlock Beach, L. I.

The third of the ferry fleet was the *Columbia*, also owned and operated by Capt. Frank Wicks. Due to the pressing need for increased ferry service, it was converted from what had been a wide, old catboat. The project required sawing the boat in half and extending it to an overall length of 50 feet. Upon completion, it held 120 passengers and very much resembled the *Atlantic*.

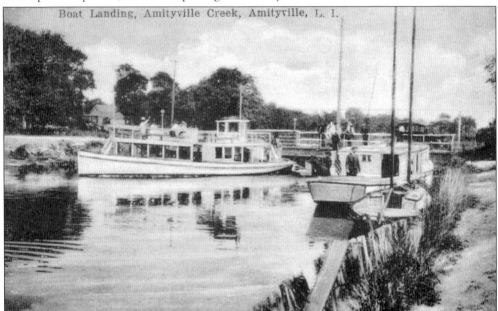

Boat Landing, Amityville Creek, Amityville, L. I.

Being larger, the *Atlantic* was used on weekends, and the smaller *Columbia*, seen here at its Merrick Road dock, was reserved for weekday use. On busy weekends, both ferries were pressed into service. The fare was 40¢ per round-trip for adults and 20¢ for children under 12. Special charters were arranged for moonlight sails, church picnics, and lodge outings. In 1921, after Frank Wicks's death, both boats were purchased by his neighbor and deckhand, William G. Conley.

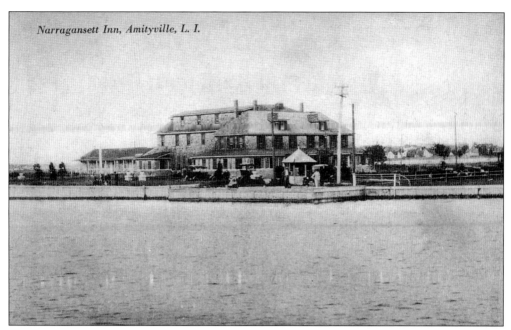

Narragansett Inn, Amityville, L. I.

After sailing past the Narragansett Inn at the end of Ocean Avenue and the mouth of the Amityville Creek, the ferries made the hour-long trip to the barrier beaches by traveling one-half mile east and then turning southward through Old Fox Creek to the Hemlock Beach heading. Due to the abundance of eel grass during hot weather, the waterways were often difficult to navigate.

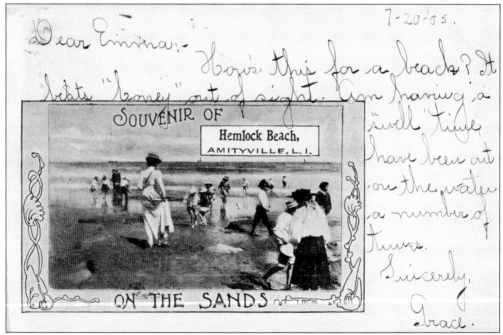

This postcard, a souvenir of Hemlock Beach, is dated July 20, 1905. During this time, postcards were often used as a primary means of communication. This postcard reads, "Dear Emma, How's this for a beach? It beats 'Coney' out of sight. Am having a 'swell' time, have been out on the water a number of times. Sincerely, Grace."

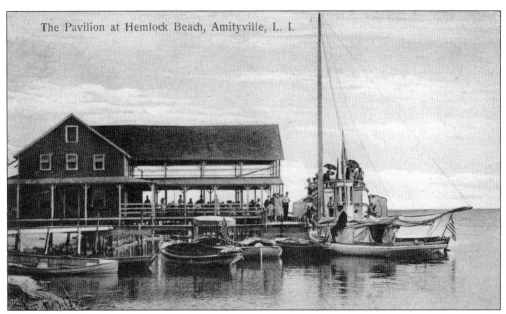

The Pavilion at Hemlock Beach, Amityville, L. I.

Once at Hemlock Beach, the hotel and pavilion operated by Wesley and Becky Van Nostrand on the north shore of the heading was the prime place to visit. From Van Nostrand's Pavilion, one could walk down to the beach, swim, enjoy a picnic on the sand, or purchase refreshments at the concession stand. Becky Van Nostrand's delicious clam chowder was renowned, and shore dinners consisting of fresh fish and fries were available for 20¢ per plate. This popular summer practice continued until 1910 when a violent storm forced a new inlet through Hemlock Beach, destroying most of the bathhouses and sanding up the channel. Many private beach houses were also washed out to sea. Although the new inlet was short-lived, it spelled the end of the popularity of Hemlock Beach.

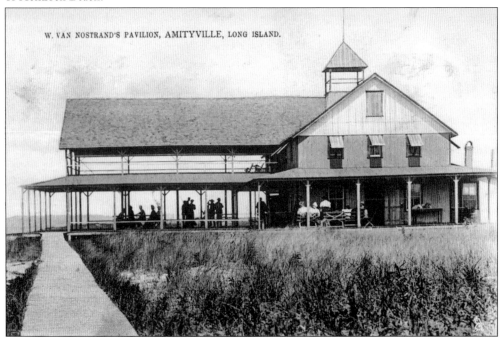

W. VAN NOSTRAND'S PAVILION, AMITYVILLE, LONG ISLAND.

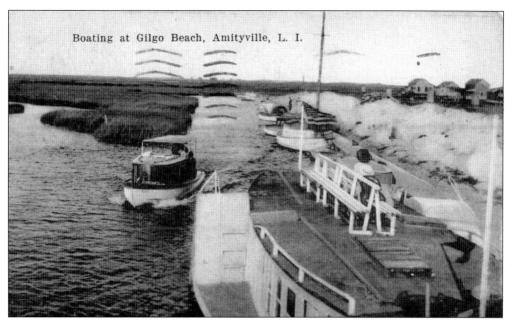

Boating at Gilgo Beach, Amityville, L. I.

After the inlet breakthrough at Hemlock Beach, many of the remaining beach houses were moved west to Gilgo Beach (seen here), which was considered a safer location. At Gilgo, a new large hotel and pavilion known as Steenbuck's was built. It boasted bathhouses, a restaurant, lively bar, and dance floor. Carl Morse, a well-known piano player, was hired by the season. Typical for its location, it had open porches on both the bay and ocean sides.

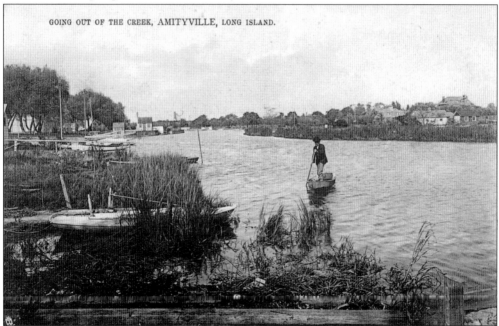

GOING OUT OF THE CREEK, AMITYVILLE, LONG ISLAND.

Until the early 1870s, there were very few people living south of Merrick Road. At that time, it was 90 percent marsh and mosquito-ridden, and natives of the area did not consider the waterfront to be the most desirable place to live. It was not until the draining and filling of the marsh that the area became hospitable to residents such as this lone oarsman, Elias Tichener Ketcham.

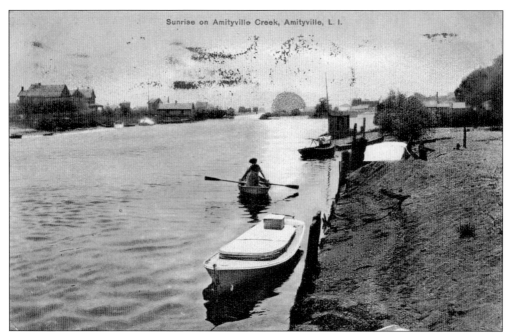

Long referred to as "the Creek," or "the Crik," this body of water is today known as the Amityville River. At the time of this late-1800s view facing south, the Crik originated from farmland several miles north, flowed quietly through what are now Peterkin Park and Avon Lake (then Ireland's Mill Pond), and under Merrick Road. It is interesting that the setting sun was incorrectly inserted by the postcard publisher, as the sun never sets in the south. More likely, this photograph was taken in the early morning, as evidenced by the duck hunter directly behind the woman in rowboat.

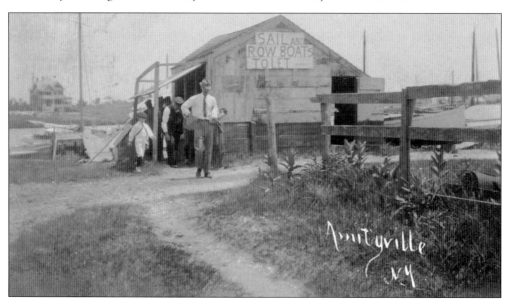

By the early 1900s, log roads were built in various places to permit accessibility to the waterfront by wagon. The 1867 arrival of the railroad increased the popularity of the area, especially for city-dwellers who sought relief from summer heat and flocked to Amityville to enjoy the cool breezes of Great South Bay. The sign on the waterside shack reads, "Sail and Row Boats to Let."

Amityville Creek, Amityville, L. I.

The large number of waterfront hotels in Amityville created a popular summer vacation destination. By the 1930s, as seasonal visitors began to show interest in staying year-round, canals were dug and cottages were built. According to author William T. Lauder in his book *Amityville History Revisited*, "More people led to more houses, less available land and higher prices, and finally to a completely built up waterfront."

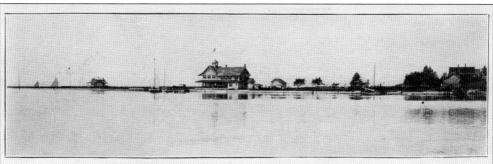

UMQUA YACHT CLUB, FROM NEW POINT HOTEL, BUENA VISTA PARK

Amityville by the Sea,
Model spot in Long Island for me,
It's just the place for a nice little home,
Twenty-nine dollars buys a lot of your own!
You should take a trip there on your next free day;
Very glad to send tickets without any delay.
Insurance we furnish free by our plan,
Liberal our terms, visit us if you can.
Look, be convinced, and then cease to pay rent;
Excursions are free—they don't cost you a cent!

Buena Vista Park and Cedar Brook Grove,
You can take your choice as through them you rove.

These lots surely will suit you, the price is not dear,
High, dry and level, the title is clear,
Express trains run often, the station is near.

So come down to the country yourself and see,
Entranced by the thought of a home you'll soon be
At Amityville by the Sea.

FOR FREE TRANSPORTATION APPLY TO

THE FEDERAL LAND AND IMPROVEMENT CO.

(INCORPORATED UNDER THE LAWS OF NEW YORK)

349-353 Fifth Avenue, at 34th Street, Suite 605, New York City, N. Y.

This postcard, mailed in 1906, offers one of the only known photographs of the short-lived Canfield's Ocean Point Hotel, which was located on the northeast corner at the intersection of Ocean and Richmond Avenues. This card was issued by the Federal Land and Improvement Company, a New York City–based corporation that invested in Amityville real estate by creating cottage sites, thereby attracting new homeowners to the area.

Scene on Amityville Creek, Amityville, L. I.

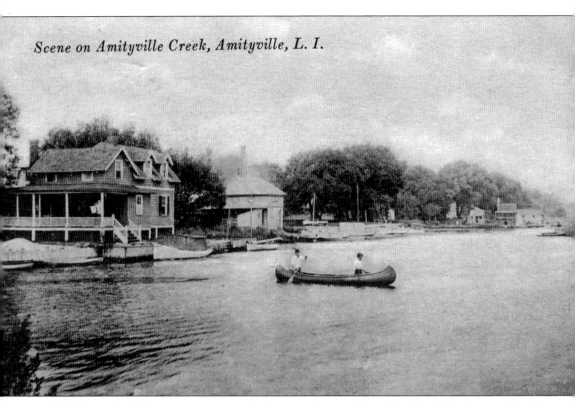

The increasingly busy waterways required seaworthy vessels, and Amityville had more than its fair share of successful boatbuilders. Although Native Americans in this area hollowed out trees to build their canoes, early white settlers had to teach themselves boatbuilding skills. As farmers and hunters, these pioneers required boats not for pleasure but to bring home food. As Malcolm Fleming writes in *A Backward Glance*, "The men who sailed the commercial boats were a colorful and hard-working lot."

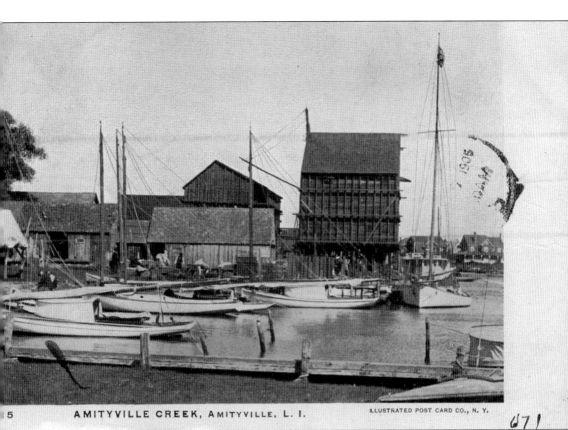

Those bay men better skilled at boatbuilding quickly developed successful careers on the water. The overwhelming need for seaworthy vessels is evidenced by the large number of boatbuilders of the day, among them the names Wicks, Ketcham, Purdy, Brown, Robbins, Sprague, Conley, Heinly, Wanser, Smith, Homan, and Hulse. By the early 1900s, the best-known local boatbuilders were the legendary Frank Wicks and his sons—Oliver, Clifford, and William. Their boatyard on the east side of Ocean Avenue, pictured here with Heinley's coal hopper in the background, produced many of the most graceful seaworthy vessels ever seen. Known for their gentleness and ease in handling, these craft were highly sought after. The most recent boatbuilders were the well-known Ketchams. The Narrasketuck, designed by Wilbur Ketcham, and Seaford Skiff, designed by Paul Ketcham can both still be seen on a clear day racing or simply sailing on the Great South Bay.

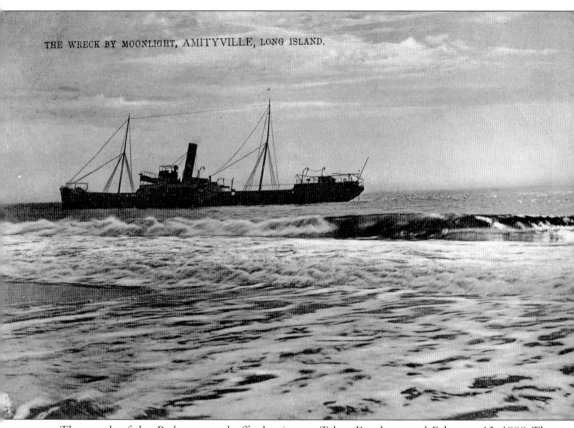

THE WRECK BY MOONLIGHT, AMITYVILLE, LONG ISLAND.

The wreck of the *Roda* occurred off what is now Tobay Beach around February 13, 1908. The *Roda* was a 315-feet-long, single-crew vessel loaded with iron pyrites, known as fool's gold. After the vessel ran aground, lifesaving crews from Jones Beach and Zach's Inlet made seven separate rescue trips. With great difficulty, they succeeded in bringing the entire crew ashore safely.

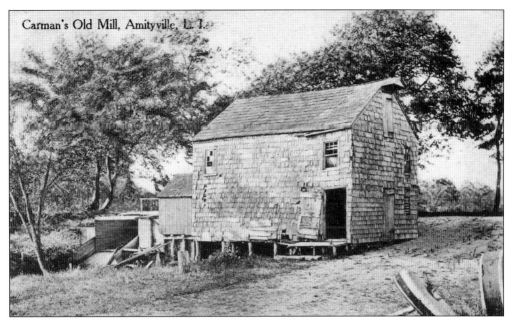

Carman's Old Mill, Amityville, L. I.

Built before 1700 and considered the first commercial enterprise in the area, Carman's Grist Mill was located on Carman's Lane, north of Kings Highway (now Merrick Road). The Carman family also operated a store, tavern, post office, stage stop, and tollgate. In *A Backward Glance*, Elodie Dibbins writes, "Weary stage coach passengers must surely have looked forward to the stop once scheduled here."

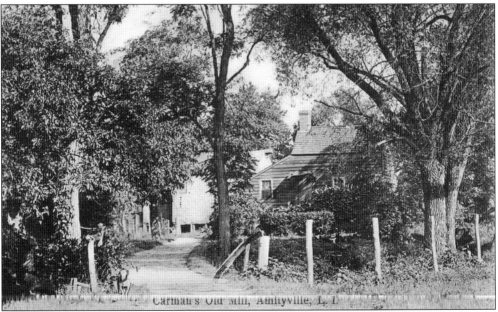

Carman's Old Mill, Amityville, L. I.

At one time, the Carman Millpond was full of water, but it has been filled in and replaced by the Berner Middle School of Massapequa. A small stream continues to run beside the school and under Merrick Road, leading to the Carman River. The mill was demolished long ago, as was the historic Carman property of several big, red barns adjoining the handsome Timothy Carman and Stephen Carman homesteads.

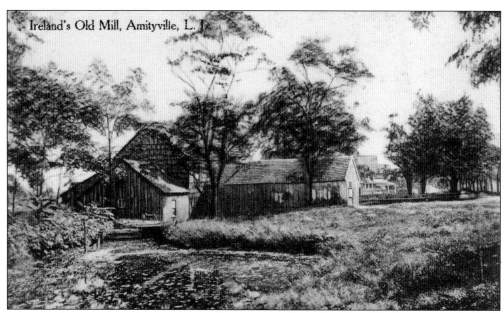

In 1750, Eliphalet Oakley established a mill on another stream east of Carman's Pond in the heart of Amityville village. In 1793, he sold the mill to his son-in-law Thomas Ireland, creating one of Amityville's first commercial enterprises. One of Amityville's founding families, the Irelands ran the mill until 1915. At the site of their stream, originally called Ireland's Brook, there was also a tavern and bakery. After the mill closed, its office was relocated to an island in Amityville Creek.

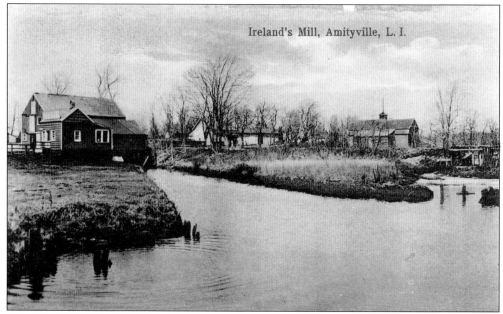

Known today as Avon Lake, this area was once known as Ireland's Mill Pond. Considerably larger than the present-day lake, the original "Big Pond" extended at least two hundred feet further to the east and west. In the early 1900s, the pond was a popular spot for ice-skating. During the winter, small bonfires were made around the pond's perimeter to help warm visitors. Eventually, the pond was dredged, and the land surrounding it was filled in.

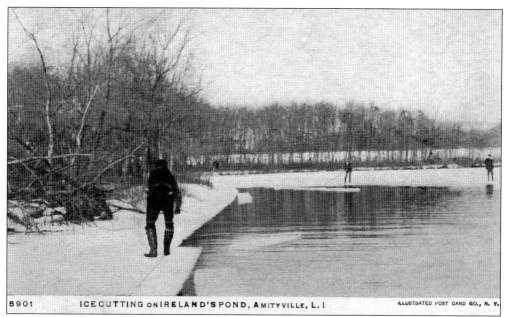

5901 ICE CUTTING ON IRELAND'S POND, AMITYVILLE, L. I ILLUSTSATED POST CARD CO., N. Y.

The old icehouse was located on the west side of Ireland's Mill Pond. Following a good winter's freeze, after the icehouse was filled to capacity, a whistle was blown to alert the townspeople that there would be enough ice for the following summer. The saved ice was stored in salt hay, which grew abundantly and provided excellent insulation. Cutting ice in those days was cold, hard work that paid a wage of about $1.50 per day.

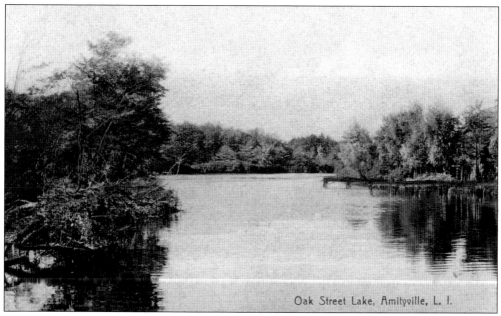

Oak Street Lake, Amityville, L. I.

Located on Oak Street, south of the railroad, is the large pond once known as Oak Street Lake. In later years, it came to be known as Hartman's Pond, named for a local family that built a large home and bottling business adjacent to the property. Until 1902, the pond supplied the Suffolk County Ice Company with enough ice to fill its nearby buildings at Lake Street each winter.

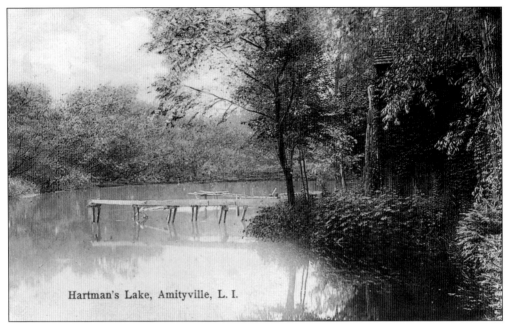

Hartman's Lake, Amityville, L. I.

A great admirer of this area was Walter J. Peterkin. In the 1950s, after he bequeathed $37,000 to develop a park around the lake, the area was named Peterkin Park. Today, the pond is a quiet spot surrounded by benches, and the park includes a popular playground. An annual Easter egg hunt sponsored by the Amityville Fire Department is held here each spring.

A Corner of Wood's Pond, Amityville, L. I.

To the east of Amityville, bordering the neighboring hamlet of Copiague, was Wood's Pond, which fed into Ketcham's Creek south of Merrick Road. Beside the creek, the original home of Zebulon Ketcham was visited by George Washington in 1790. Old deeds indicate that an Indian wigwam was once located here. Today, as part of the Ketcham's Creek Wetlands Restoration, the pond, although greatly reduced in size, tries valiantly to reach the Great South Bay, as it once did.

Four

AMITYVILLE'S
FORGOTTEN ERA
THE GRAND HOTELS

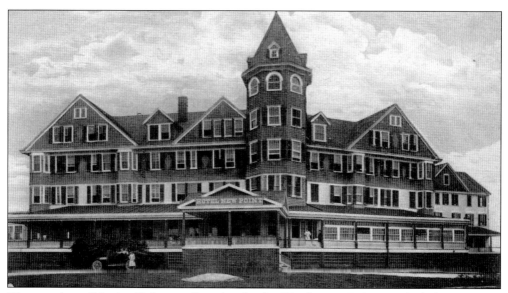

The grandest of Amityville's waterfront hotels, the Hotel New Point was built by Ewen M. Hathaway and developed by John E. Ireland. At the time of its construction in 1892, it provided employment for a large number of well-known local carpenters. The Victorian, three-and-a-half-story structure included 60 guest rooms, a large dining room on the north end, and large verandas overlooking the Great South Bay.

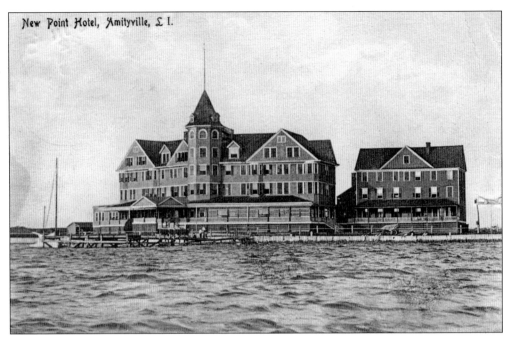

New Point Hotel, Amityville, L. I.

The extensive grounds of the Hotel New Point, also known as the South Shore Holiday House, included a bathing beach with private bathhouses and a carriage house available for guests who arrived by or rented a horse and buggy while staying at the hotel. On nearby Dewey Avenue during the season between May and October, Powell's Livery Stables operated an annex to its main building, offering rental transportation and groom service for hotel residents who brought their own horses. The Powells also operated a shuttle service between the railroad station and the hotel for the many guests visiting from Brooklyn and New York.

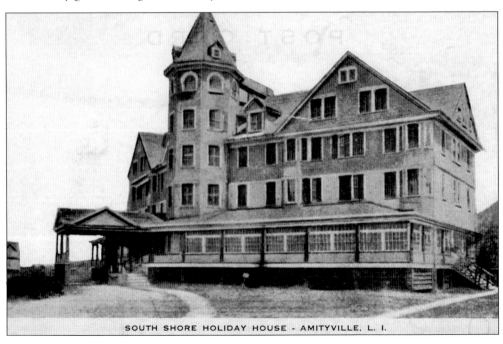

SOUTH SHORE HOLIDAY HOUSE - AMITYVILLE, L. I.

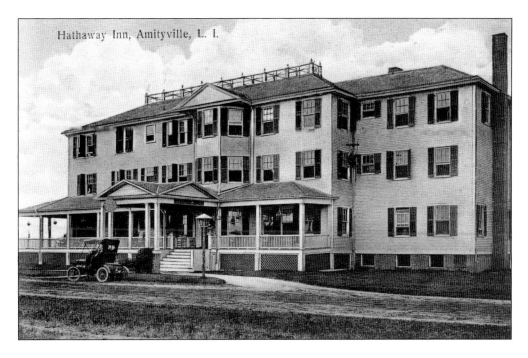

Hathaway Inn, Amityville, L. I.

The hotel business flourished to such an extent that by 1900, a second hotel referred to as the New Point Inn was built nearby on the west side of Grand Central Avenue. Eventually, Ewen M. Hathaway closed the larger hotel and confined his activities to the newly named Hathaway Inn. Operating as a summer-only hotel, it could accommodate up to 75 guests, who were provided with bathing facilities and large verandas on both the bay and inland sides. A 1928 travel brochure lists the weekly rates at $15 to $25 dollars for room and board.

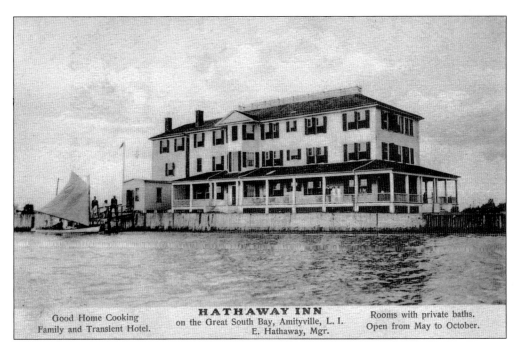

Good Home Cooking
Family and Transient Hotel.

HATHAWAY INN
on the Great South Bay, Amityville, L. I.
E. Hathaway, Mgr.

Rooms with private baths.
Open from May to October.

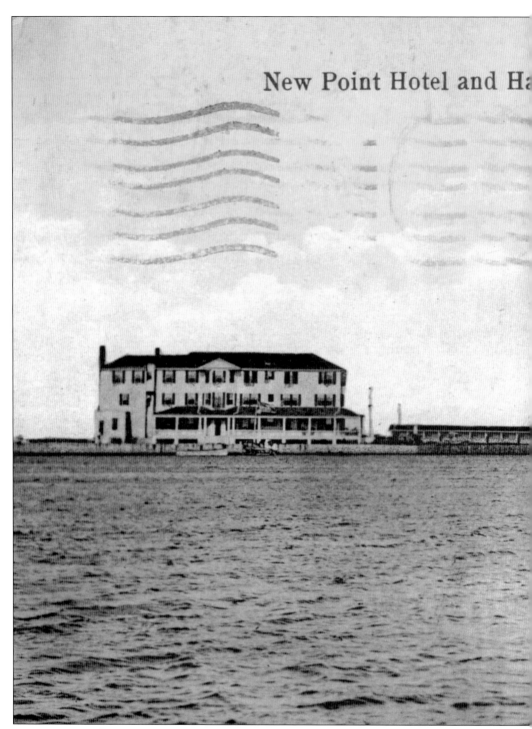

New Point Hotel and Ha

In 1916, twenty-four years after the Hotel New Point's grand opening, an auction was conducted to sell all the contents. In later years, other uses were found for the imposing structure, including a gala fundraising event by the American Cancer Society at which Paul Robeson performed. During the 1930s and 1940s, the Fresh Air Fund, sponsored by the *New York Herald Tribune*, used

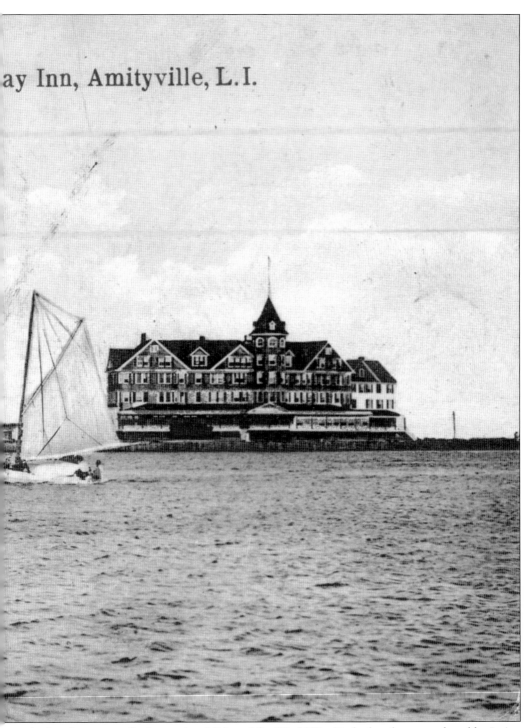

ay Inn, Amityville, L.I.

the hotel as a camp for inner-city children. After World War II, the hotel was purchased by Irving Shaw, who established the Meroke Day Camp. Vacant for several years, the once elegant hotel was destroyed by a mysterious fire occurring in 1962. On November 10, 1951, following a busy summer season, a devastating fire had also destroyed its sister hotel, the Hathaway Inn.

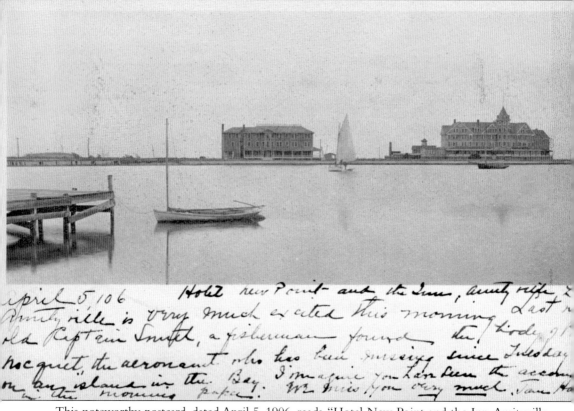

This noteworthy postcard, dated April 5, 1906, reads, "Hotel New Point and the Inn, Amityville, Long Island. Amityville is very much excited this morning. Last night old Captain Smith, a fisherman, found the body of Paul Nocquet, the aeronaut who has been missing since Tuesday morning on an island in the bay. I imagine you have seen the account in the morning papers. We miss you very much," and is signed by Jane Hawes. The headline of the *New York Times* dated the same day reads, "Balloon Empty, Aeronaut Dead. Paul Nocquet Expires in a Long Island Marsh." Further, it reports that the balloon landed safely on a sandy beach, but Nocquet tried valiantly to swim to Amityville and expired in the effort.

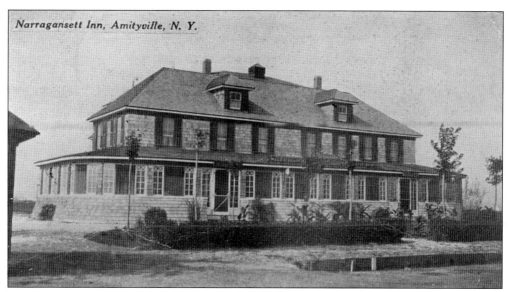

The Narragansett Inn, originally known as the Conklin House, had 28 rooms and was located on the southeast corner of Ocean and Richmond Avenues. This busy intersection was also the south terminal of the Amityville-Huntington Cross-Island Trolley. The first proprietor, Bernard Conklin, took full advantage of the spectacular waterfront location by providing guests with boating excursions on the bay. From the hotel's dock, William Conley operated the *Ella C.*, while Josh Burch sailed the *Barney Conklin*.

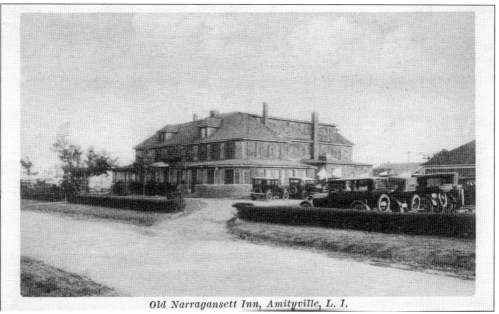

Old Narragansett Inn, Amityville, L. I.

During Prohibition, the hotel and restaurant operated year-round under the new name Shanahan's. Musical entertainment was often provided on weekends. In 1940, Peter Nemiroff, owner of the Russian Kretchma Restaurant in Manhattan, bought the hotel and changed the name, yet again, to the Shangri-La. On April 1, 1965, after the restaurant had closed for the evening, a fire ignited in the kitchen, destroying the structure and thereby eliminating the last of Amityville's grand waterfront hotels.

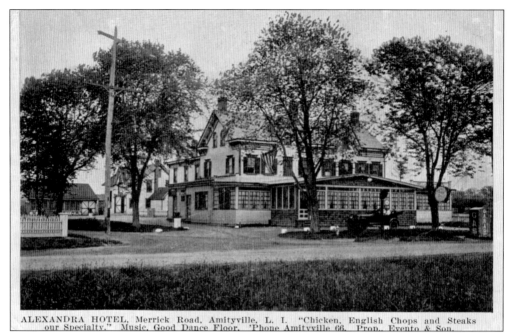

ALEXANDRA HOTEL, Merrick Road, Amityville, L. I. "Chicken, English Chops and Steaks our Specialty." Music, Good Dance Floor. 'Phone Amityville 66. Prop. Evento & Son.

Located on the northeast corner of Bayview Avenue and Merrick Road, the Alexandra Hotel was owned and operated by Nicholas Evento. Convenient to both downtown and the waterfront, it offered visitors music and a lively dance floor. Specialties of the house included chicken, English chops, and steaks. During the Vanderbilt Cup races, the Alexandra Hotel hosted both the racers and their cars. Later, the hotel became known as Shanley's Tavern.

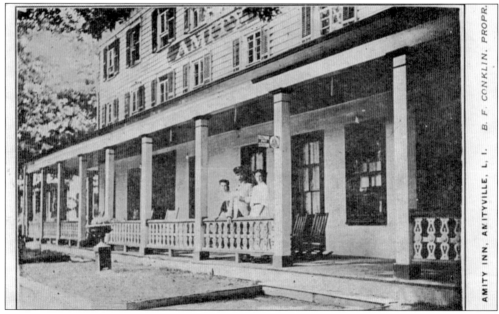

Prior to his stint as proprietor of the Conklin House (later the Narragansett Inn), Bernard Conklin operated the Amity Inn. This hotel was centrally located at the intersection of Broadway and Merrick Road, which at the time was referred to as "the" Merrick Road. The Amity Inn hosted participants of the great New York–Amityville bicycle race of 1899.

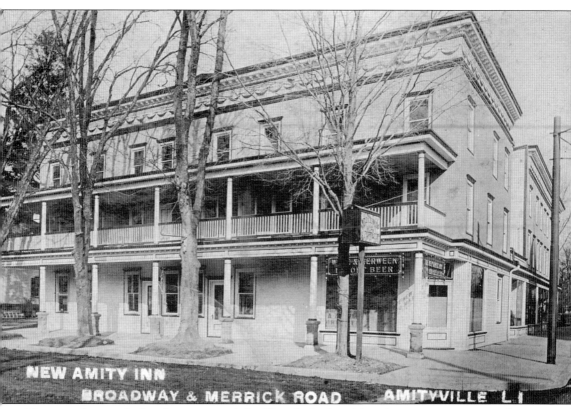

NEW AMITY INN
BROADWAY & MERRICK ROAD — AMITYVILLE L. I.

After several years, the hotel was renamed the New Amity Inn. Many improvements were made to the building, which included decorative detail molding along the eaves and the second-story addition of sheltered balconies with columns and spindles. These balconies overlooked the busy Merrick Road. The building in which the inn was housed became known in later years as the Elliott Building, named after the owner. In this photograph, an advertisement for local brewery Welz & Zelwerk, located nearby on County Line Road, indicates that the inn most likely includes a corner tavern.

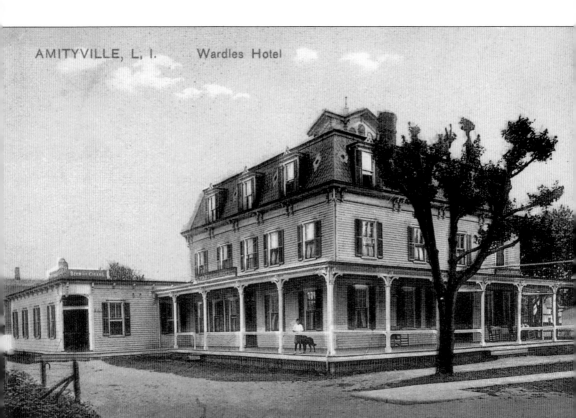

AMITYVILLE, L, I. Wardles Hotel

In 1870, Wardle's Inn was located on Broadway, near the railroad station. Owned and operated by Thomas Wardle, the inn provided 25 guest rooms and a convenient location for businessmen who traveled to Amityville. A popular restaurant and tavern was located behind the hotel. From its street-side front veranda that faced Broadway, one could keep a close eye on the daily comings and goings of the downtown area. The hotel was later renamed Kiernan's and later still became known as the Hotel Amityville.

Five

BUSINESS AS USUAL

BANKS, SCHOOLS, LIBRARIES, AND HOSPITALS

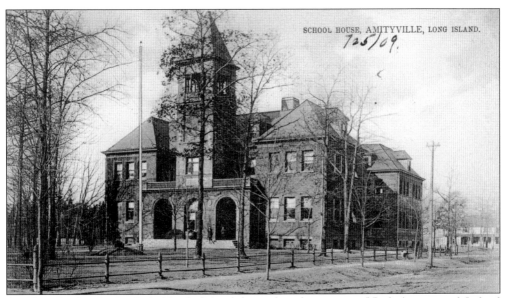

A village landmark, the Park North School, located at the corner of Park Avenue and Ireland Place, was built in 1894 to replace the original three-room wooden schoolhouse, which occupied the same location. Built in 1872, the tiny school had become inadequate for the rapidly growing school district. The obsolete school building was sold to local businessman Frank Smith for use as a dry goods store and was moved around the corner to the west side of Broadway opposite Avon Place, where it still stands, virtually unchanged, today.

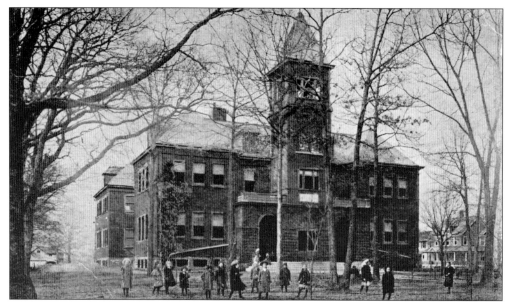

In 1894, the interior of the new, modern Park North School included six classrooms, an auditorium, reception room, gymnasium, library and teachers' room. As it was the only high school in the area, students were transported from many surrounding communities as well as from the small branch school located on Albany Avenue in North Amityville. That same year, Amityville Union Free School District No. 6 was integrated, forcing the closure of the then separate school.

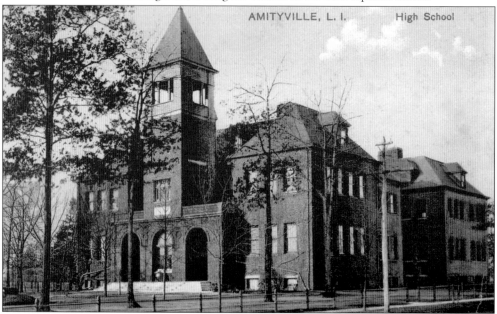

Unique to the grounds of the original building were a spiked harbor mine and a horse block at the Park Avenue curb for those arriving by carriage. Two Civil War cannons with surrounding piles of cannon shot flanked the front walk. A bell tower transplanted from the previous schoolhouse signaled the familiar start of each school day. When the structure was first built, no student was allowed to enter through the front doors which were reserved, out of respect, for visitors and special occasions.

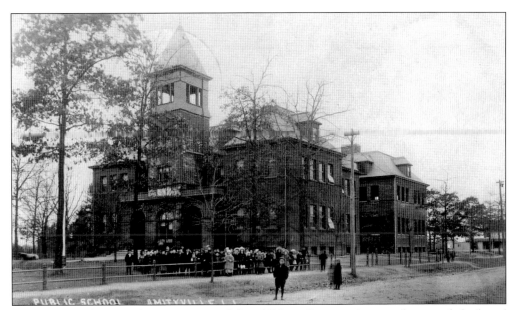

By 1907, growth in population necessitated the addition of a west wing, seen here newly built and vacant. In their turns, the mine, cannon, and school bell were removed. The cannons contributed to the nation's scrap-metal drive during World War II, and the bell was moved to a pedestal at the school's northeast corner. In 1978, the west wing was demolished after the original building, no longer serving students, became the school district's central administration office.

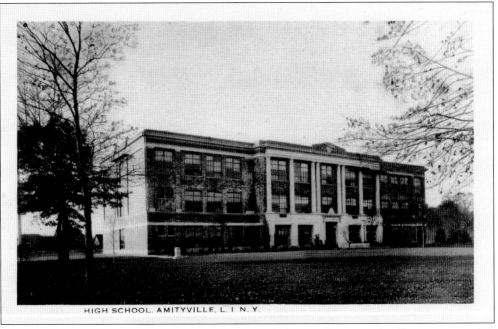

By 1923, the student population had increased so much that another new schoolhouse was needed. Located just south of the original Park North Building, this school was referred to, not surprisingly, as the Park South Building. This modern structure was used as the high school, while the original older building continued to serve as the grammar school. Students traveled from the neighboring communities of Massapequa, Seaford, Wantagh, and Copiague to attend the new school.

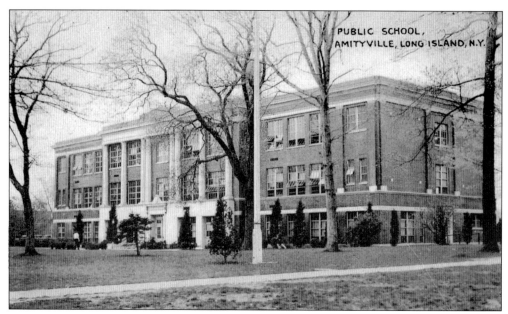

In 1932, Amityville again saw a need for more classroom space, especially for junior high school students. As a result, yet another school building was erected with a facade identical to that of the existing high school, just to the south. Although the original designs included a central section connecting the two buildings, this was not constructed. With three school buildings in the same location, they were referred to as Park North, Park Central, and Park South.

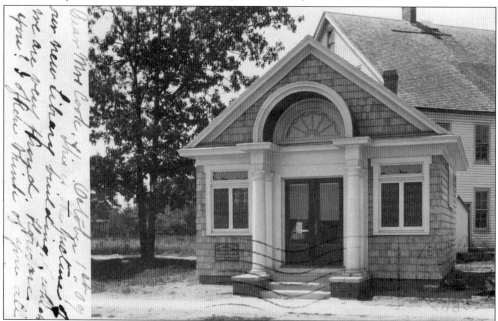

In 1902, the Amityville Literary Society held a meeting at the home of Mary P. Myton, which was located at the southeast corner of Merrick Road and Richmond Avenue. Each member was asked to bring a book and initial it. By 1906, as the collection grew to 67 books, the parish hall of St. Mary's Church became the library's headquarters. Shortly thereafter, a subscription drive allowed for construction of a small wooden building on the west side of Broadway near Ireland Place.

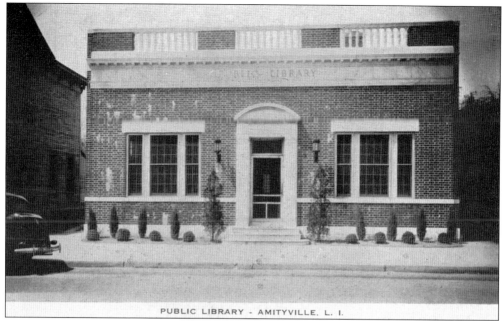

PUBLIC LIBRARY - AMITYVILLE. L. I.

By 1926, as the population grew, the small building became outmoded and was sold and moved to Belmont Court to be used as a private residence. In its place, a more substantial brick structure, built by the well-known and prolific A.A. Pearsall, became the home of the Amityville Free Library. Caroline Moul Fitz, although not the first librarian, was the first to be certified and the last one to serve in this building during her tenure.

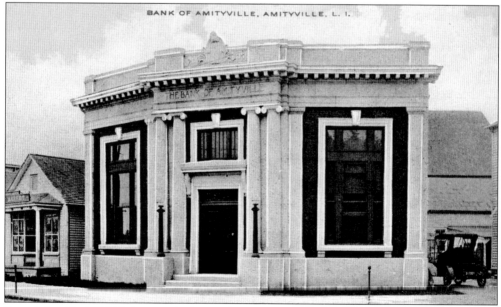

BANK OF AMITYVILLE, AMITYVILLE. L. I.

Founded with $25,000 in capital, the Bank of Amityville was the first and only bank in the Town of Babylon in 1891. Originally located within the Triangle Building, it sought a new, larger location by 1909. Twenty-two-year-old Lewis Inglee, a graduate of both Amityville High School and the Pratt Institute of Technology, was chosen as the architect. William T. Lauder remarked that Inglee's Beaux-Arts design "projected the strength and soundness expected of a successful bank."

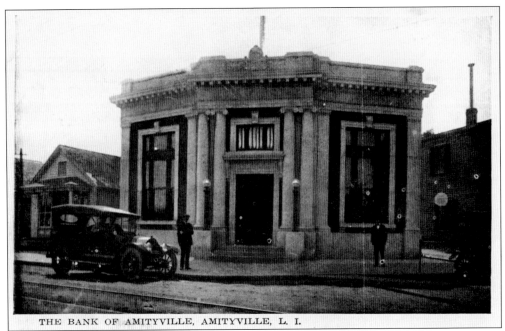

THE BANK OF AMITYVILLE, AMITYVILLE, L. I.

Upon completion of the bank's grandiose design, 26-year-old Augustus A. Pearsall, a local mason contractor and builder, was hired to construct the marble and brick structure. Pearsall, a grandson of Civil War veteran Ezra Pearsall, prided himself on the quality of his buildings, many of which remain standing in Amityville today.

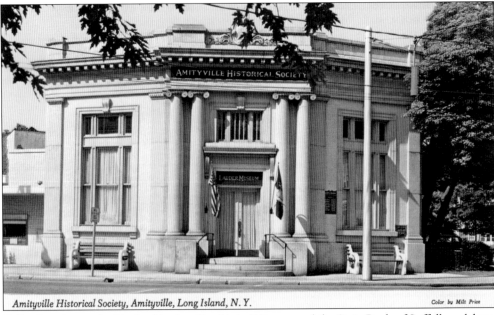

Amityville Historical Society, Amityville, Long Island, N.Y. Color by Milt Price

Following closure the Bank of Amityville, this building served the State Bank of Suffolk and, later, Franklin National Bank. In 1971, through negotiations initiated by William T. Lauder, Franklin National Bank agreed to donate the building to the fledgling Amityville Historical Society. Founded in 1969, the society, led by its first president, Dorothy W. Krayer, succeeded in transforming the venerable old bank into a vibrant historical museum named in honor of Lauder's efforts.

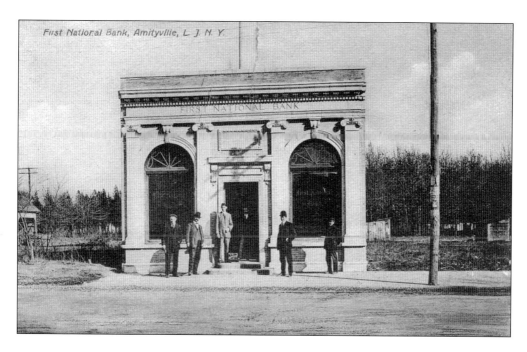

First National Bank, Amityville, L. I. N. Y.

Erected in 1907, the First National Bank and Trust Company is seen above, with five of its original directors standing out front. Located on the east side of Broadway between Oak Street and Union Avenue, it was later enlarged to include a central two-story section and south wing, as can be seen in the photograph below. In 1927, the bank was relocated to a new, more formidable building on the southwest corner of Broadway and Greene Avenue. During the 1960s, the First National Bank and Trust Company became part of Security National Bank.

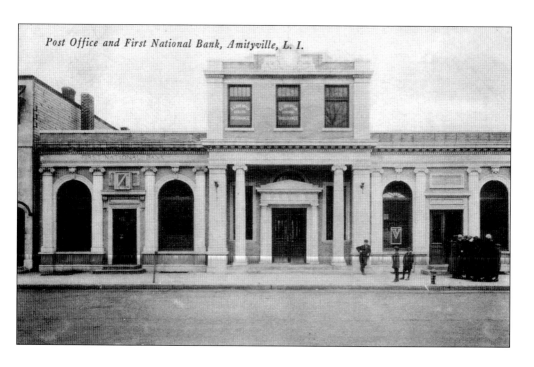

Post Office and First National Bank, Amityville, L. I.

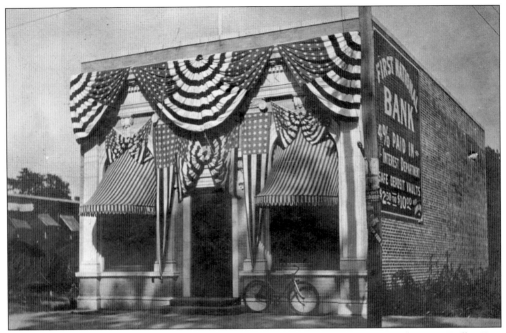

Decorated in patriotic bunting, the First National Bank and Trust Company is seen here on Trolley Day, August 25, 1909. This event celebrated the inauguration of the Cross-Island Trolley, which operated between Huntington and Amityville. On the right side of the building, interest rates are advertised at four percent, with the cost of safe-deposit vaults ranging from $2.50 to $10 per annum.

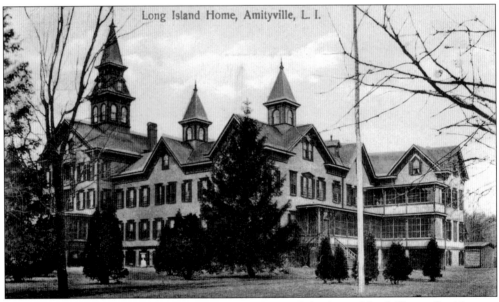

In 1881, John F. Louden, originally from Maine, opened the Long Island Home for Nervous Invalids along with other investors. Serving as a restful place to escape from the rigors of daily life, it catered mostly to the privileged and well-to-do members of society. With its gabled roof and graceful spires, this recognizable building was the largest single enterprise in the village and provided employment for many of its residents.

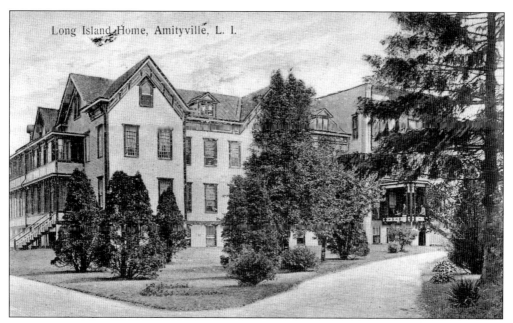

Long Island Home, Amityville, L. I.

In 1884, after a disagreement between the stockholders, Louden disassociated himself from the Long Island Home. Leaving Amityville, he moved to New Jersey to become the manager of a hotel; however, his keen interest in providing health care prevailed. In 1886, Louden acquired considerable property on both sides of Division Avenue and opened a small sanitarium that he named Louden Hall. Today, Division Avenue is called Louden Avenue, named in his honor.

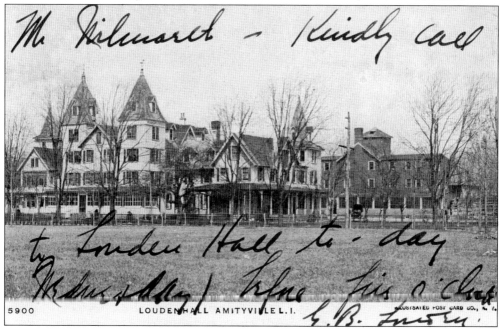

5900 LOUDEN HALL AMITYVILLE L.I.

This undated postcard of Louden Hall reads, "Mr. Wilmarth- Kindly call to Louden Hall to-day, Wednesday, before five o'clock, signed G.B. Louden." An early information circular distributed to patients and their families lists John F. Louden as proprietor, James F. Vavasour, MD, as physician in charge, and Robert O. Willmott, MD, as assistant physician.

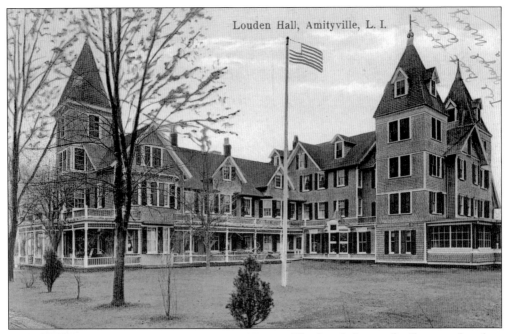

Louden Hall, Amityville, L. I.

In the Grounds, Louden Hall, Amityville, L. I.

The hospital was a family-owned-and-operated business, with four of Louden's children holding responsible positions. Son William T. Louden, in addition to his duties at the hospital, served as supervisor for the town of Babylon from 1920 to 1922. John F. Louden Jr. became a medical doctor and served as Amityville's first official mayor in 1921, as well as the hospital's superintendent until 1928. John F. Louden III followed in both his father's and grandfather's footsteps, becoming the last family member to fill the position of superintendent in charge of the hospital.

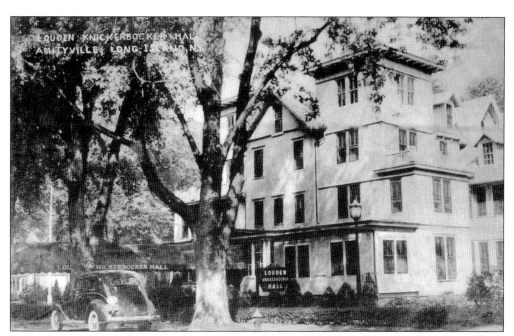

In 1913, the Louden family added Knickerbocker Hall, increasing the scope of their services to include an adjunct sanitarium and rehabilitation facility. Located at 81 Louden Avenue, the newly named Louden-Knickerbocker Hall billed itself as a private hospital "specializing in the care and treatment of nervous and mental disorders; also drug addicts and alcoholics." No patient was received for less than four weeks. It was mandatory that payment be made in full upon admission to the hospital.

A Quiet Spot, Louden Hall, Amityville, L.I.

The manicured grounds of the Louden facility served patients and their visitors well. Across the street on the south side of Louden Avenue, a large farm was established to serve the hospital and its administrators. It was called Neduol, which is Louden spelled backwards. The fully developed farm included cultivated crops and livestock such as cows, horses, chickens, and pigs that freely roamed the property.

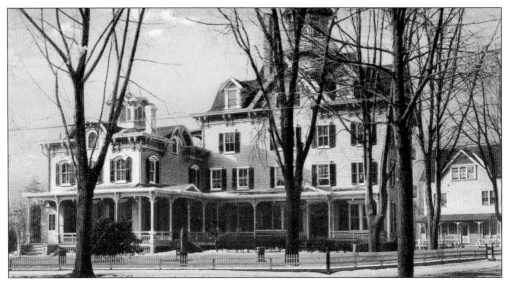

In 1887, the Brunswick Home and Hospital opened on Broadway to the east of Louden Hall. In November 1940, the original structure burned to the ground in a horrific fire that killed six patients, and a new Brunswick Home and Hospital was built. In 1962, Louden-Knickerbocker Hall was absorbed by Brunswick Home and Hospital. As a result, the Brunswick Hospital Center became the largest private hospital in the United States. A change in ownership in March 2000, coupled with increased health care costs, caused Brunswick Hospital to close its doors for good in 2005; however, the Long Island Home survives and includes the South Oaks Hospital and Broadlawn Manor Nursing and Rehabilitative Center.

The Reed General Hospital, a fourth health care facility, was opened in 1923 by Dr. Theodore D. Reed, who acquired a large Victorian home at 52 Park Avenue from the estate of A.W. Haff. The hospital consisted of 22 rooms. At its peak, staff included two additional doctors and as many as 16 nurses. Dr. Reed took pride in his policy of never refusing a patient for inability to pay. The hospital closed in 1941.

Six

The Sporting Life

Recreational Clubs

and Entertainment

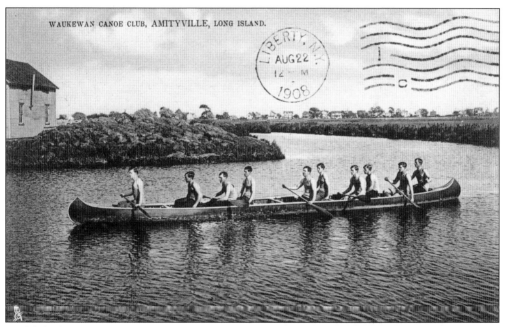

WAUKEWAN CANOE CLUB, AMITYVILLE, LONG ISLAND.

Established during the 1890s, the Waukewan Canoe Club was a small organization of athletic young men. Without a clubhouse to call their own, they held meetings "downtown" in the Triangle Building. Known for their use of long canoes that held 8 to 10 men, they rowed the waters of the Great South Bay at speeds of six to eight knots and thought nothing of paddling as far as Freeport or Bay Shore for lunch.

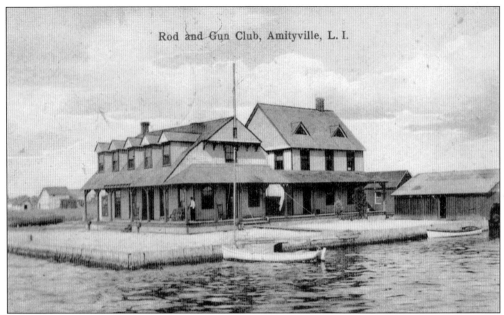

Rod and Gun Club, Amityville, L. I.

Considered the oldest sporting club in Amityville, the Gilbert Rod and Gun Club had its beginnings in 1884 in a barn on Ocean Avenue near Bourdette Place. Fully incorporated in 1894 by a group of out-of-town sportsmen, the club built a proper waterside clubhouse the same year on property acquired on the east side of the Amityville Creek and McDonald Avenue. Consisting of well-to-do men mostly from New York City and Brooklyn, members referred to themselves as "Yorkers." Their interests were primarily sailing, fishing, and gunning—a common term for duck hunting. Members made use of the nine-room clubhouse, primarily during weekends when they were renowned for their extravagant parties. The name "Gilbert" was taken from treasurer W.K. Gilbert, who served in that position from 1894 to 1902.

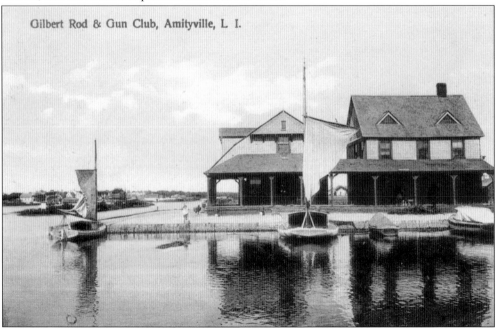

Gilbert Rod & Gun Club, Amityville, L I.

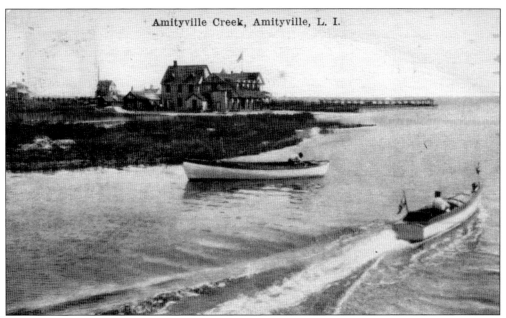

Amityville Creek, Amityville, L. I.

By 1944, only seven members of the club remained. Their advancing ages, as well as the costs associated with maintaining the clubhouse, annex, bulk heading, boathouses, and surrounding grounds, led to the club's demise. "We've been called the 'old men's club' and although we're well along in years, we feel pretty young," claimed H.D. Hammond, club president and treasurer. On September 30, 1944, an important era in Amityville's history ended when ownership of the property was transferred to a New York City physician. Dr. Leslie O. Ashton, the new owner, had intended to raze the original building and rebuild after the end of World War II; however, this never took place. Today, the original structure, now a private residence, continues to sit proudly aside the bay, commanding breathtaking views of the Amityville River.

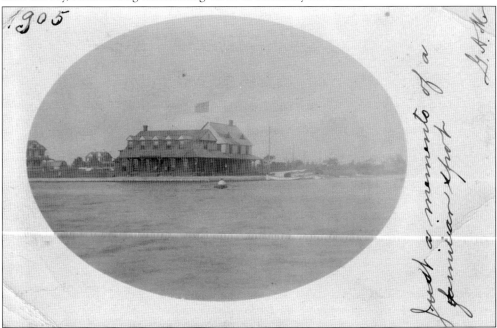

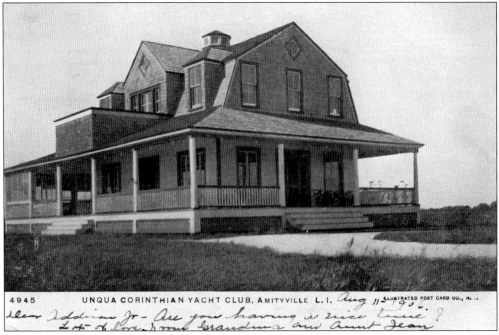

4945 UNQUA CORINTHIAN YACHT CLUB, AMITYVILLE L. I. *Aug 11 1906.* ILLUSTRATED POST CARD CO., N. Y.

Dear Addison Jr - Are you having a nice time? Lots of love from Grandma and Aunt Jean

Located on Great South Bay at the foot of Unqua Place, the Unqua Corinthian Yacht Club was established in 1900. Originally a salt marsh, the land was donated by John E. Ireland. Initially, sailing was the main club activity, and women were only invited on special occasions. In 1928, facilities were expanded to include a dining room and kitchen wing. Around that time, the club initiated one of its most popular events—the Saturday evening dinner dance. In the image below, officers raise the flag during opening-day ceremonies. Within several generations of its founding, Ireland's son, grandson, and great-grandson each rose to the position of club commodore.

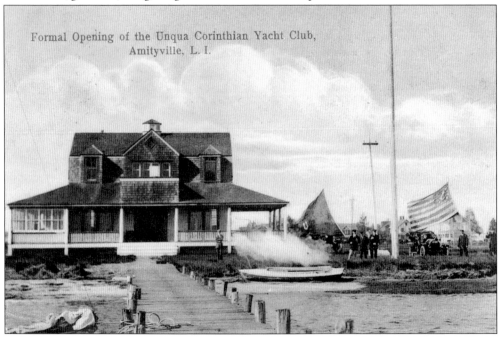

Formal Opening of the Unqua Corinthian Yacht Club,
Amityville, L. I.

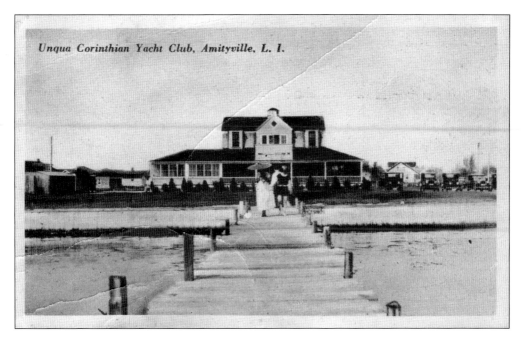

Unqua Corinthian Yacht Club, Amityville, L. I.

During the early 1930s, the cross-bay channel was dredged, and a private beach station referred to as "the Heading, was acquired by Unqua at West Gilgo Beach, just east of Jones Beach. In 1965, an Olympic-sized swimming pool was installed on the club grounds and, as a result, the club has become well known across Long Island for its competitive swim teams. Sailing continues to be a common pastime among club members. In 1992, the nearly century-old clubhouse was extensively remodeled. Today, with an active and enthusiastic membership, the Unqua Corinthian Yacht Club continues to be as popular as when it was first established over 100 years ago.

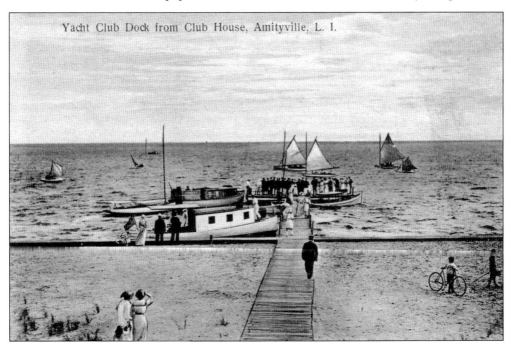

Yacht Club Dock from Club House, Amityville, L. I.

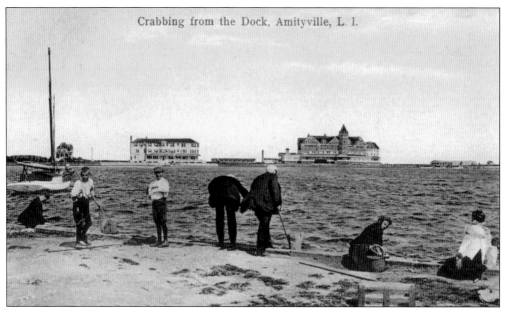

Crabbing from the Dock, Amityville, L. I.

Crabbing along the waterfront such as the village dock, shown here, has always been a common activity for adults and children alike in Amityville. In the old days, a decent haul could be had using just string and some bait, such as salt pork or fish heads. Many Amityville youngsters sold their catch for a penny apiece to local fish markets, such as Bill Ketcham's, located at the foot of Coles Avenue.

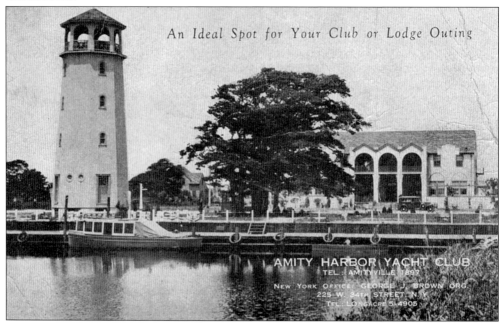

An Ideal Spot for Your Club or Lodge Outing

AMITY HARBOR YACHT CLUB
TEL : AMITYVILLE 1897
NEW YORK OFFICE: GEORGE J. BROWN ORG.
225 W. 34TH STREET, N. Y.
TEL. LONGACRE 5. 4905

Just beyond the eastern border of Amityville, the Amity Harbor Club House and Marina was created by the George J. Brown Organization in 1926. Advertised as "exclusive but not expensive," it boasted more than six miles of bulkhead, two sandy beaches, a clubhouse, and a 55-foot-tall observatory in the shape of a lighthouse. Unfortunately, the stock market crash of 1929 and ensuing Great Depression halted the development's progress for three decades.

4320 CLUB HOUSE, AMITYVILLE, L. I. ILUST. POST CARD CO., N. Y.

found kitten alright. All well. Anna.

The Amityville Club, located on Merrick Road just east of Broadway, is shown here. Founded exclusively for men in 1897, the club held retreats in which billiards, card playing, and smoking were the primary activities. Beginning around 1914, club members organized a theatrical troupe that appeared on the stage of the second-floor auditorium. Their performances were always popular and well received.

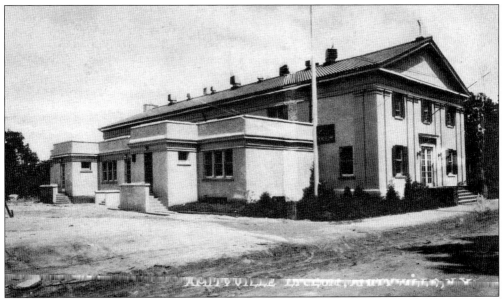

In 1892, the much-loved Amityville Lyceum was built on Park Avenue on the site of what had been previously referred to as Ireland's Grove. Built as a community social hall, it served as theater, dance hall, temporary church, and held other public and private functions. Like many old structures, it ultimately suffered a fire and was torn down. As a result, the St. Martin's school building, shown here, was temporarily used as the lyceum.

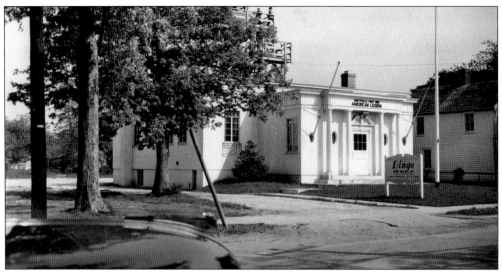

The Amityville American Legion Post No. 1015 was established in 1919. Located on Park Avenue, it is seen here in the early 1940s. Famous for Tuesday night bingo and countless village social events, this original building was destroyed by fire in 1960. Shortly thereafter, it was rebuilt in the same location, and today, it serves as home to the New Testament Church.

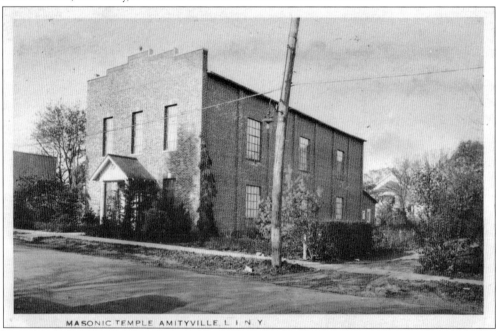

MASONIC TEMPLE AMITYVILLE, L I N Y

The Free and Accepted Masons Lodge No. 977 was first established in Amityville with a membership of 50 men in 1920. Arthur Wells, a former master in the Babylon lodge, was nominated for master in the newly formed club. The original meeting place, Fraternity Hall on Greene Avenue, quickly proved too small for the growing membership. By 1921, property on the north side of Avon Place near the corner of Broadway had been purchased from St. Mary's Church. On October 20, 1922, the cornerstone of the new temple was laid amongst nearly 1,000 Masons from all of Long Island. Preceding the dedication ceremony, a parade through the gaily decorated streets of the village took place. That evening, a gala celebration took place in the new building.

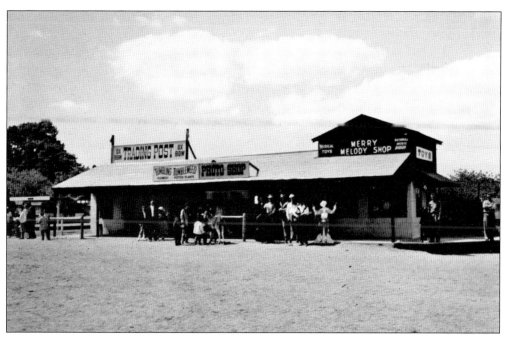

During the 1950s, Frontier City was a popular Western-themed amusement park located on Broadway in North Amityville. The park consisted of an authentic Western-style Main Street, which included a hotel, saloon, and a leather shop. A town hall and a café were situated down the street. Actors dressed in Western attire roamed throughout the park, entertaining the crowds, and rodeos took place in the center of "town." Actors played Indians among teepees on the nearby "reservation." The Trading Post housed the souvenir stand and photography shop. Boot Hill Cemetery simulated a large mountaintop dotted with the make-believe graves of cowboys who had participated in one too many gunfights.

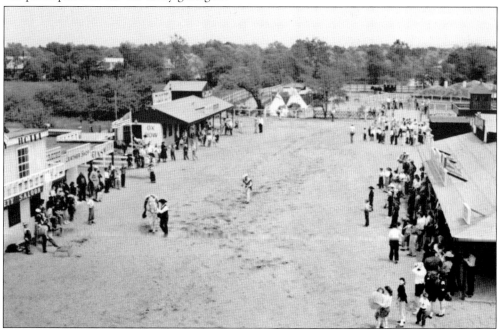

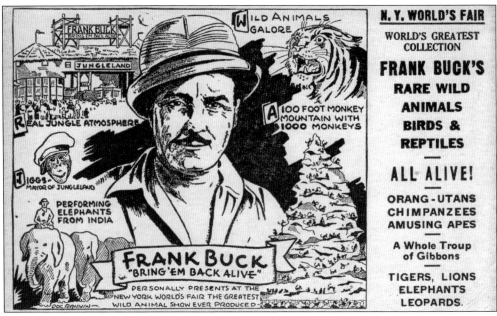

From the 1930s to the 1950s, the Frank Buck Zoo, owned by Frank Buck—the famous "Bring 'Em Back Alive" big-game hunter—was located on Sunrise Highway, just west of Carman Mill Road. Attracting thousands of visitors to the area, the menagerie included elephants, giraffes, lions, tigers, and an occasional leopard. Guided sightseeing tours were available for up to six people atop the elephants. The most popular attraction was the large concrete monkey mountain, seen here. Surrounded by a moat, the monkeys were free to roam the mountain as visitors enjoyed their antics. More than one monkey was known to escape the zoo, only to be rescued days later in the nearby woods of Massapequa. Sadly, the advent of World War II led to the zoo's demise, although during the late 1940s and 1950s, it continued to function on a smaller scale under the name Massapequa Zoo.

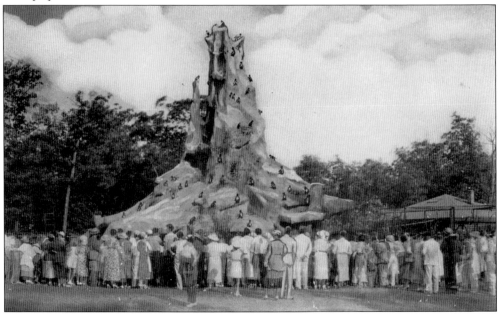

Seven

GETTING AROUND TOWN
RAILROADS AND TROLLEYS

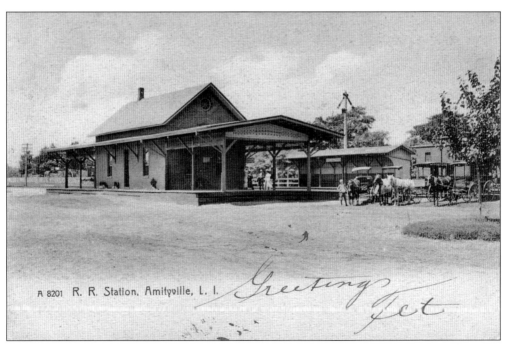

A 8201 R. R. Station, Amityville, L. I.

In 1867, the South Side Railroad was extended through Amityville to Babylon Village. A station house opened south of the tracks just east of Broadway. At that time, travelers could get to and from New York in just under an hour, not unlike today. A new station was later built at its present location just west of John Street, and the old depot was renovated for use as a private residence.

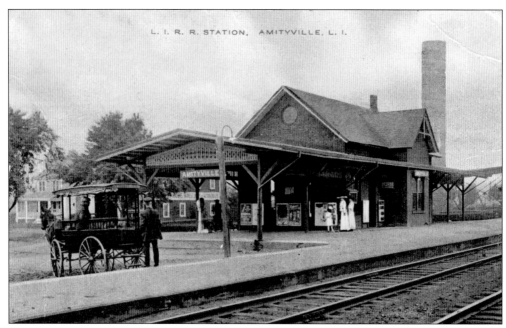

L. I. R. R. STATION, AMITYVILLE, L. I.

This postcard, originally postmarked in 1917, depicts passengers awaiting the eastbound train from New York. The stagecoach and driver from the nearby Leigh's Livery Stable await their charge in the foreground. Also seen in this photograph is a weighing scale, which was popular at the time and provided as a service for waiting passengers. Note the water tower in the background.

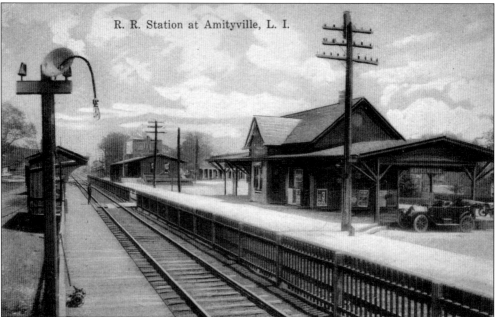

At one time, Amityville was an important stop on the Long Island Rail Road's lively freight line. The station had both a freight agent and passenger agent, along with several men employed at the freight station. Before electrification to Babylon in 1925, there was a daily freight train serving stops from Rockville Centre to Babylon. In this 1906 photograph, the freight station is seen just east of the passenger depot.

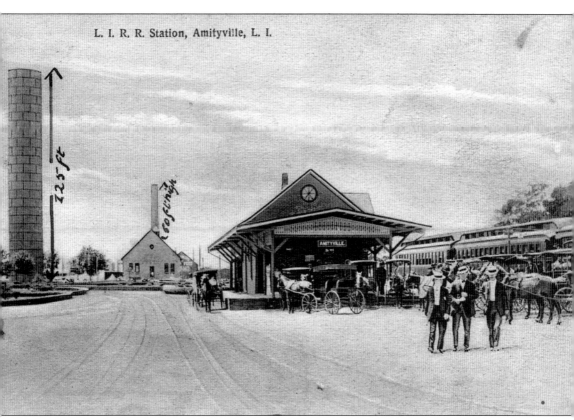

L. I. R. R. Station, Amityville, L. I.

125 ft.

This c. 1898 photograph was taken during the evening rush and features summer commuters wearing their straw skimmers as they emerge from the eastbound train from New York. In the background on the left, the elaborately landscaped Electric and Water Company buildings are visible. Handwritten on the face of the card is the water tower's height, 125 feet. The oversize clock shows the time as 7:25 p.m.

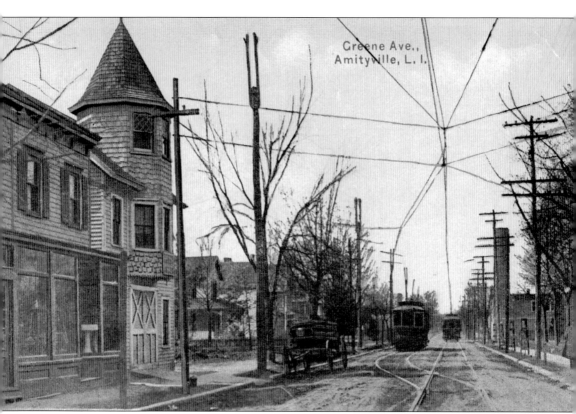

Greene Ave.,
Amityville, L. I.

During the early 1900s, two separate trolley lines existed in Amityville. In 1909, the Long Island Rail Road (LIRR) opened the Cross-Island Trolley, which operated between Halesite in Huntington and the foot of Ocean Avenue in Amityville. In 1910, the South Side Traction Company, under the auspices of the Babylon Rail Road, opened a line connecting the village of Babylon to the Amityville LIRR depot, via Lindenhurst and Copiague. In this rare photograph, both trolleys are seen crossing each other, the East-West Trolley stopped on the siding on the left while the Cross-Island Trolley approaches on the right. In 1892, Greene Avenue was created just west of Broadway by developing the woods previously known as Ireland's Grove. In addition to the trolley tracks that ran along it, this busy street was the location of the police department, the fire department, and a plumbing shop, which later became the home of the local newspaper, the *Amityville Record*.

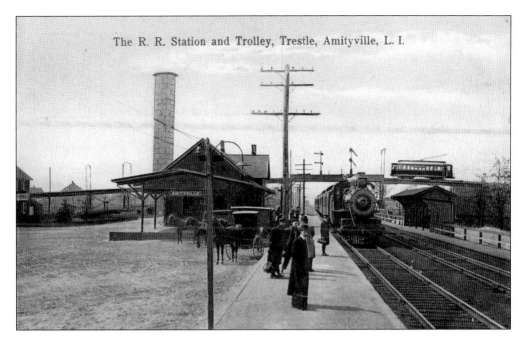

The R. R. Station and Trolley, Trestle, Amityville, L. I.

The Cross-Island Trolley is depicted here crossing the trolley trestle. In the above c. 1911 photograph, several formally attired businessmen glance eastward just as the incoming Long Island Rail Road train pulls into the station. The enclosed (or winter) trolley passing overhead travels south from Huntington. In the photograph below, taken several years earlier, an open-air (or summer) trolley takes a similar route. In 1919, the Cross-Island Trolley went out of business, and the Babylon Trolley Line followed in 1920. In just a few short years, improved roads and the popularity of the motorcar rendered both trolley companies obsolete. Later, the trolley trestle was used as a footbridge.

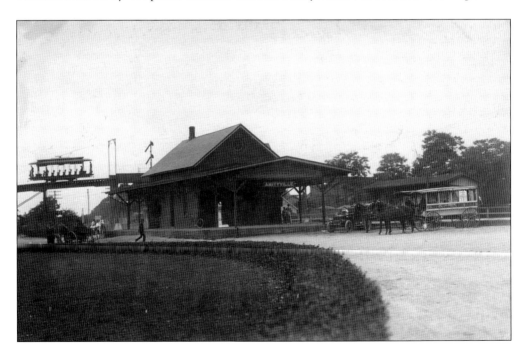

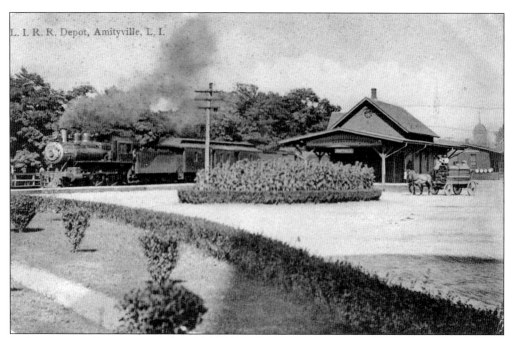

In this photograph, a New York–bound express steam locomotive cruises past the Amityville station. It was not until the late 1940s that the diesel train replaced the steam engine east of Babylon. As can be seen in this image, efforts were being made in the way of municipal landscaping to include native plantings such as this beautiful canna garden.

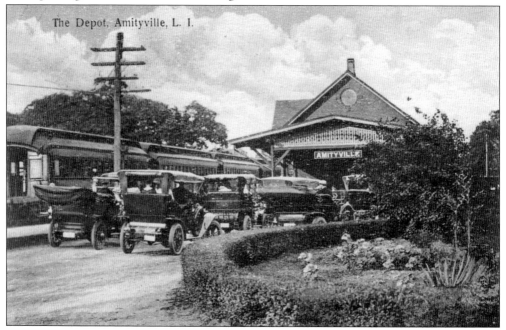

Seen here around 1910, the Long Island Rail Road station proves to be a popular place at rush hour—not unlike today. Many early automobiles, such as the Model T Fords seen here, are delivering or receiving commuters and visitors alike. The area surrounding the station continues to be enhanced by thriving and fully developed landscaping.

Eight

KEEPING THE TOWN SAFE
AMITYVILLE'S "FINEST AND BRAVEST"

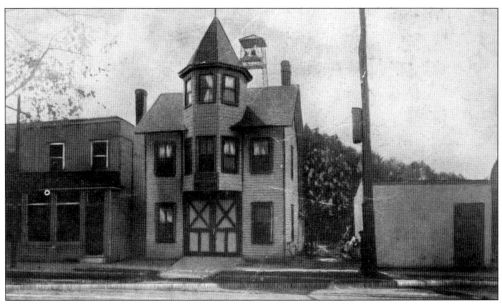

Prior to 1886, local firefighting was limited to bucket brigades and fire equipment such as hoses and hand-pump wagons stored in local barns near the livery stable. In response to a boom in the construction of many large wooden buildings, a new three-story, Victorian firehouse with turret, seen here in about 1891, was built on the south side of Greene Avenue, housing the Hook and Ladder Company No. 1.

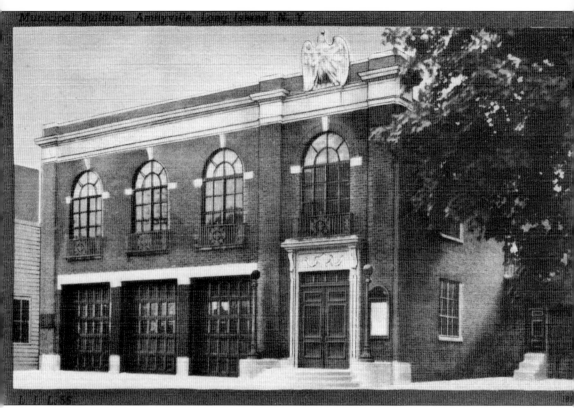

In 1893, Hose Company No. 1 was formed with headquarters located on Merrick Road, east of the Amityville River. The Dauntless Hose Company No. 2 was founded the following year with headquarters on Mill Street. By 1905, the three companies merged to form the Amityville Fire Department. In 1924, a new brick firehouse was erected on the Greene Avenue site of the original Victorian building, which was bought and relocated by Charles Delano, editor of the *Amityville Record*.

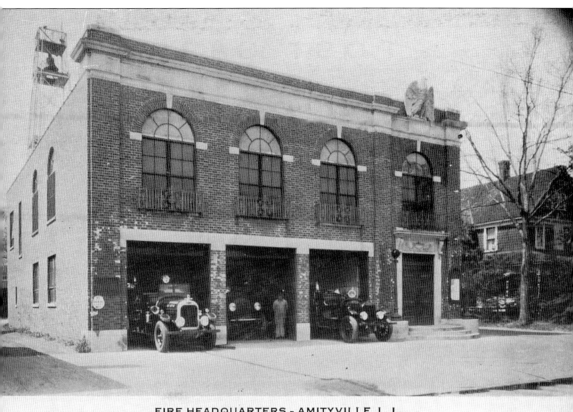

FIRE HEADQUARTERS - AMITYVILLE, L. I.

In 1977, new fire headquarters were erected on West Oak Street on the site of the old Henry Leigh Livery Stables. The 1924 building was remodeled for use by the police department and village courts. The Amityville Police Department was first organized in 1894, the year of the village's incorporation. Provided with a badge and cap, Charles Howenstein was appointed constable at a salary of $15 per month. A short while later, the village board appointed Edwin H. Stratton to be chief. At that time, the police department consisted of three officers. One officer patrolled during the day shift, while the other two officers handled the night watch at a salary of $50 per officer per month. During the early years of the department, most arrests were for public intoxication and vagrancy. A brick jail consisting of two cells was located at the corner of Greene Avenue and Burch Avenue.

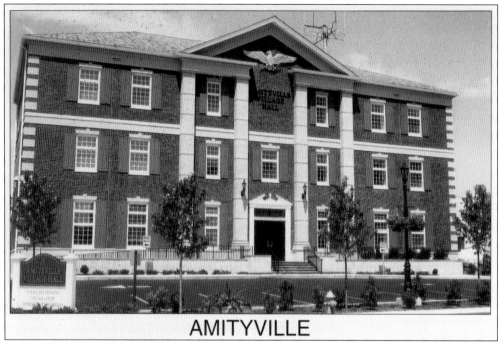

AMITYVILLE

In 2009, the police department, offices of village administration, and village courtroom moved to a new 15,000-square-foot, three-story brick building, one of the largest in the village and located on Ireland Place. The structure was designed using recycled materials to reduce energy consumption, and upon its completion in June 2009, the Village of Amityville was awarded the North East Partnership's Green Building and Energy Efficiency Award.

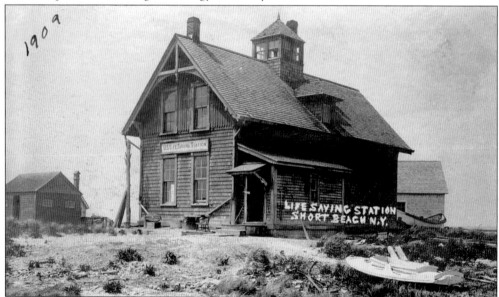

After many severe winters and 300 wrecks in nine years along the Long Island and New Jersey coasts, Congress enacted measures to provide eight small lifesaving stations. Prior to 1870, the crews were volunteers; however, within eight years, keepers were paid at a salary of $200 per year. By 1881, the keeper was paid $700 annually.

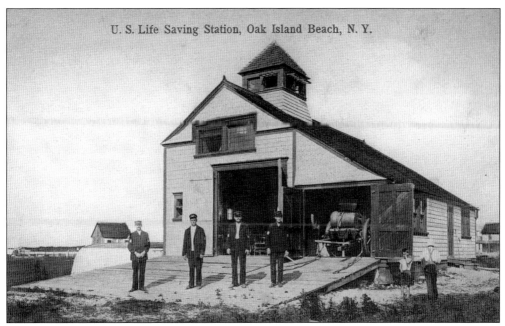

U. S. Life Saving Station, Oak Island Beach, N. Y.

By 1900, twenty-nine lifesaving stations existed along the south shore of Long Island. Local crews were recruited from experienced baymen. Three crewmen and the keeper are pictured here at the US Life-Saving Station at Oak Island Beach. According to Cecil Ruggles in *A Backward Glance*, "The men were skilled in wind, weather and tide and could maneuver surf boats expertly enough to snatch a shipwrecked mariner from a watery grave."

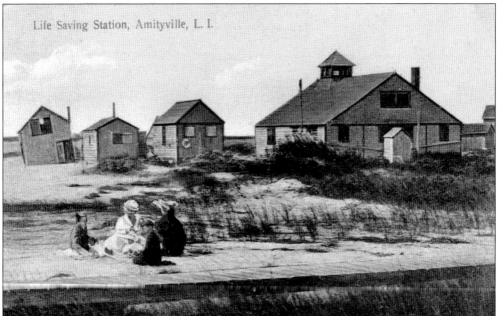

Life Saving Station, Amityville, L. I.

Life in the old stations could not have been easy. A tour of duty consisted of four to six weeks without ever leaving the beach. Each member took his turn in the kitchen, and bread was baked every third day to feed the voracious crews. Each September, 20 tons of coal used for heating and cooking was towed through the bay, deftly maneuvered to shore, and carried up to the stations.

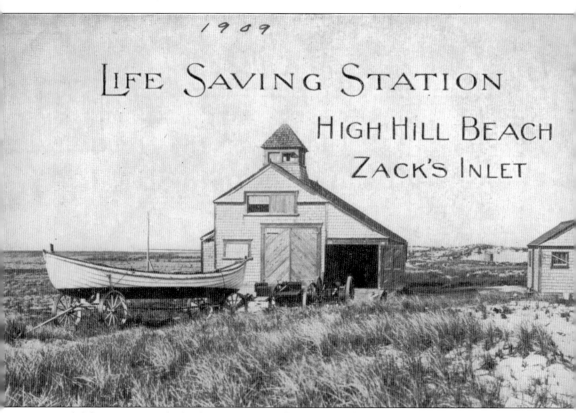

1909

LIFE SAVING STATION
HIGH HILL BEACH
ZACK'S INLET

Each lifesaving station had at least 12 men on four-hour shifts patrolling the beach. One man from each station walked about two miles, and crewmen met one another halfway between stations. On stormy nights with high tides, it was necessary to walk the dunes. Shortly after World War I, the lifesaving stations were discontinued as it was decided that they were no longer needed.

Nine

A Spiritual Foundation
Amityville's Churches

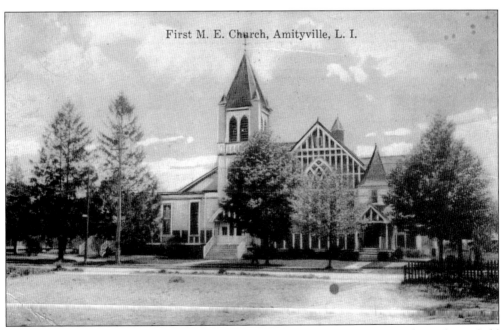

First M. E. Church, Amityville, L. I.

In 1792, the first Methodist class in Amityville, then called Huntington West Neck South, was held in the home of Elijah Chichester. In 1823, the First Methodist Church, also referred to as South Church, was built on Merrick Road. Later moved to the southwest corner of Cedar Street and Broadway in 1845, the original Greek Revival structure has undergone extensive restoration and now serves as the law office of Richard G. Handler.

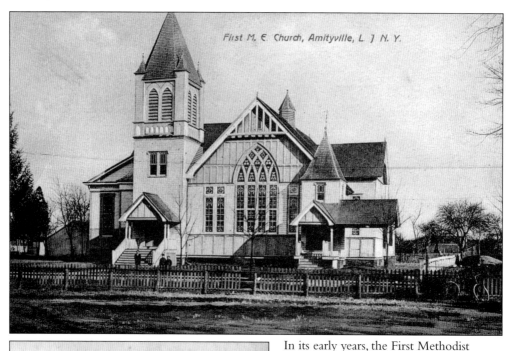

First M. E. Church, Amityville, L. I. N. Y.

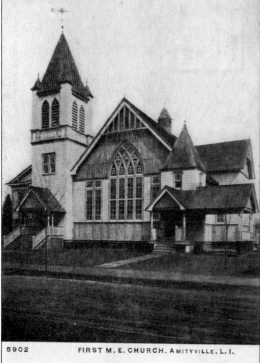

5902 FIRST M. E. CHURCH, AMITYVILLE, L. I.

ILLUSTRATED POST CARD CO., N. Y.

In its early years, the First Methodist Church was strictly divided into two sections. One was reserved for women, and the other for men. However, a then recently married couple, J. William and Mary Jane Willmarth, broke this tradition by sitting next to each other during services. The husband was given a hearing by church elders, at which he made such a reasonable plea in his own defense that the time-honored rule was abolished.

A second church built on Merrick Road roughly opposite Richmond Avenue in 1845 was moved to its present site on Broadway in 1867. A growing congregation required a larger church, and in 1891, the cornerstone was laid. Members of the building committee included staunch Methodist families such as the Ketchams, Irelands, and Weeds. The dedication ceremony was attended by Rev. G. W. Servis of the North Amityville Methodist Church.

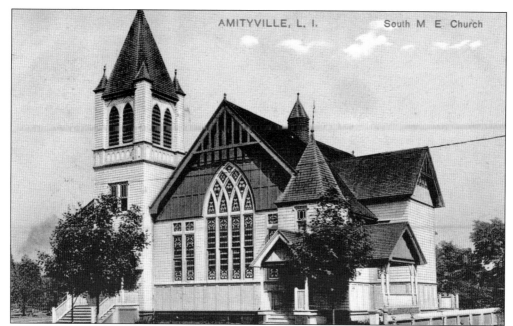

In 1921, an 1880 sanctuary organ and 1887 pipe organ, both built by Hilbourne Roosevelt, were acquired. In 1939, remodeling added new classrooms, a chapel, parish hall, library, parlor, kitchen, and children's chapel. A donation funded installation of the stained-glass window over the pulpit. Acquired property included the large Georgian Colonial home of Christian Dittman, which today houses the Church Attic, a thrift shop staffed by members of the United Methodist Women.

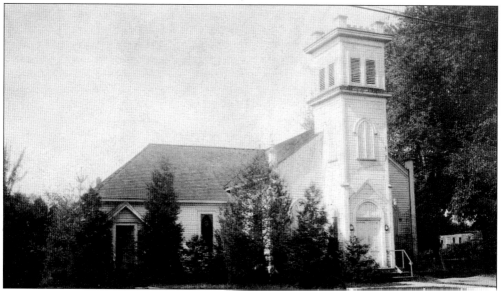

The Simpson United Methodist Church, named in honor of Methodist bishop Matthew Simpson, a friend of Abraham Lincoln, is the second-oldest church in Amityville. In 1869, it was established to oblige northern farmers who felt the location of South Church was inconvenient. Unfortunately, in 1932, New York State took control of the church property to expand Sunrise Highway into Suffolk County. A temporary home was found in the former Frank Smith Dry Goods Store on Broadway.

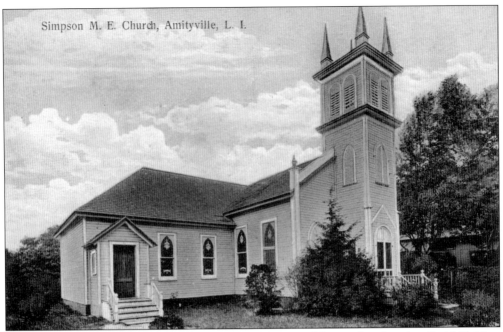

Simpson M. E. Church, Amityville, L. I.

In 1933, a new church was built upon five acres northwest of the previous location. In 1960, New York State once again claimed control of the property in order to build a cloverleaf intersection. The church temporarily combined with the South Church for Sunday services. In 1963, the church reopened on Locust Avenue. The new church had a 90-foot-tall steeple with a golden cross at the top and a head of Christ rose window in the narthex.

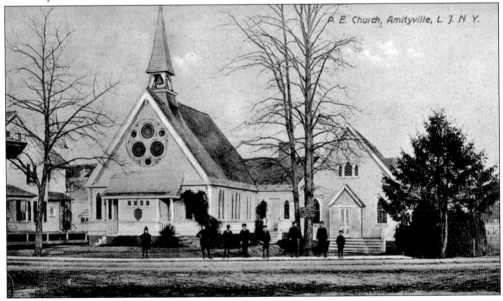

P. E. Church, Amityville, L. J. N Y.

Established by Rev. James Herriot Noble in 1886 as a mission, St Mary's Episcopal Church is the third-oldest of Amityville's many churches. The Episcopal congregation first met in the home of William Skinner. The present church was built in 1889 upon a quiet wooded site on the east side of then Amityville-Huntington Road, now Broadway. Although the main building has remained as originally constructed, other major changes have taken place through the years.

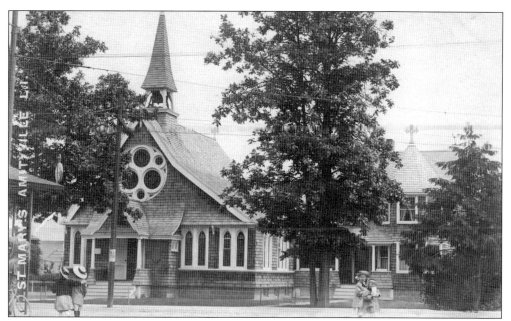

In 1902, a parish house was constructed south of the main church and was later moved to the rear of the church in 1908. The church was widened to allow for a south aisle, and a rectory was constructed on the site previously occupied by the parish hall. Parish status was granted by the Diocese of Long Island in 1921. Memorial stained-glass windows were added to the nave, and a pipe organ installed in 1936 was replaced by a Baldwin electronic organ in 1955. In 1952 and again in 1959, the state assumed property to increase the width of Broadway, which moved closer and closer to St. Mary's front door. The parish hall has continued to serve the community in many ways, including as a temporary grammar school in 1904 and a library in 1908. Today, it serves as home to the Grace Day School Nursery School.

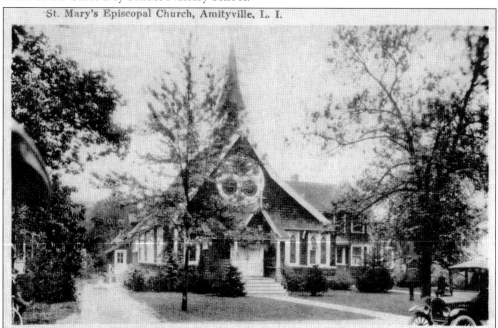

St. Mary's Episcopal Church, Amityville, L. I.

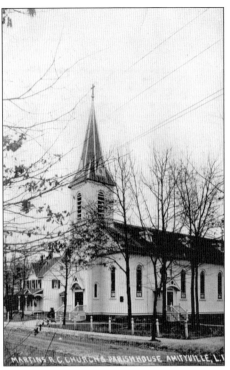

St. Martin of Tours Roman Catholic Church was originally established as a mission of St. Killian's in Farmingdale in 1897. In 1899, Bishop McDonnell dedicated the first frame church (seen here), with a congregation of 30 families. A school was organized in the basement of the church in 1918. A Von Jenny pipe organ was installed in 1920, and one year later, a proper schoolhouse—with eight classrooms and an auditorium—was erected.

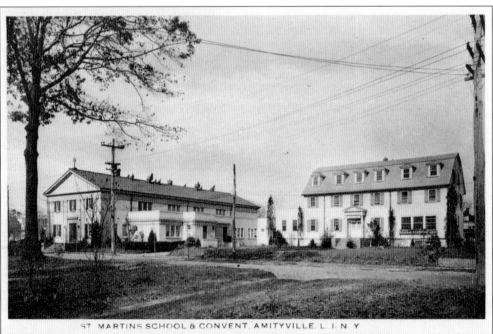

By 1963, the original church had been demolished to make way for a larger one. While construction was under way, Mass was celebrated in the new school wing, completed in 1956. Building was complete within one short year, and the new church was dedicated on May 24, 1964, by Bishop Walter P. Kellenberg of the Rockville Centre Diocese. Relics from the old church, including the original altar and several stained-glass windows, found a home in the new church.

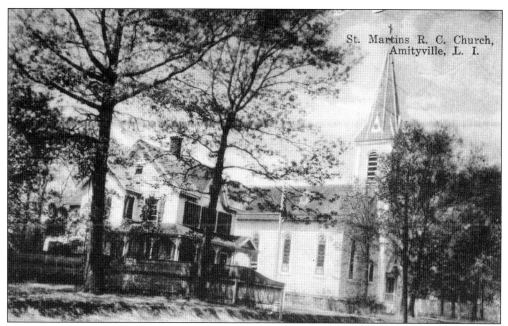

St. Martins R. C. Church,
Amityville, L. I.

The most recognizable feature of the new St. Martin of Tours Church were the Angelus bells, which rang forth their familiar tones from the new steeple rising above the front entrance. For many decades, villagers became accustomed to setting their watches to the ringing of the bells twice each day at noon and 6:00 in the evening. To this day, as one enters the village, the soaring white steeple is a visible part of Amityville's skyline.

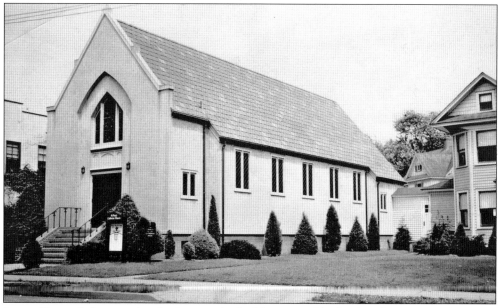

In an effort to bring together Lutherans who had been worshipping in other communities, Rev. August Brunn and William T. Koepchen founded St. Paul's Lutheran Church in 1930. The first service took place in the First National Bank on Broadway. Shortly thereafter, the congregation built a church on Park Avenue on property owned by Christian Dittman. Today, the church is known for its 26 stained-glass windows, stone facade, and lovely chimes.

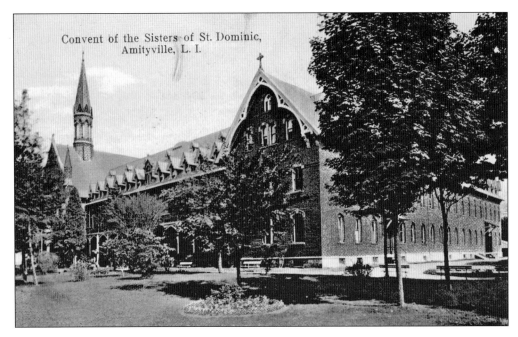

Convent of the Sisters of St. Dominic,
Amityville, L. I.

This postcard depicts the Church of the Holy Rosary and Convent of the Sisters of St. Dominic. The Sisters of St. Dominic, a Roman Catholic religious order, was first established in 1215 in Regensburg, Germany, on the Danube River. In 1853, four nuns came to the United States from their cloistered community to teach the children of German immigrants. Although they intended to move to Pennsylvania, the congregation instead came to Long Island via Williamsburg, Brooklyn, after a parishioner offered his summer cottage in North Amityville during 1876. On 18 acres of what was once farmland, the sisters established the Queen of the Rosary Convent, Novitiate, and Academy, a vast complex devoted to religious life and learning.

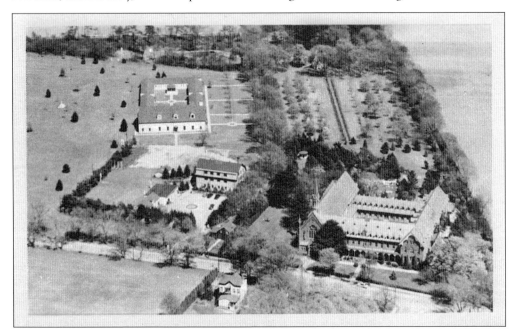

As depicted in this photograph of two novices strolling on Rosary Lane beside the Wayside Crucifix, the Sisters of St. Dominic also hosted weekend retreats for laywomen on the pastoral grounds at the Our Lady of Prouille Retreat House. The Queen of the Rosary Academy was a popular high school, which at its peak drew over 800 high school students to its all-female campus located in North Amityville. As with many Long Island Catholic schools, dwindling registration led to the much-loved school's closing in 1986, despite widespread protest, after enrollment dropped to less than 250 students.

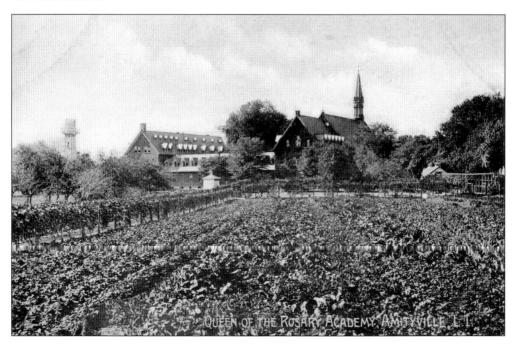

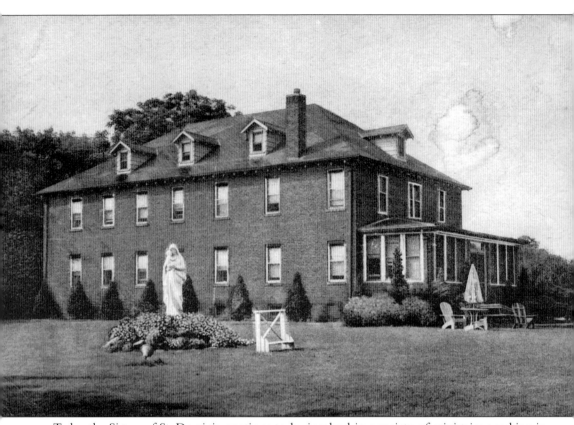

Today, the Sisters of St. Dominic continue to be involved in a variety of ministries, working in education, health care, and spirituality. The 53-acre complex includes Rosary Hall Chapel and Queen of the Rosary Motherhouse (seen on page 102), built in 1876 in the Gothic Revival style by New York City architect William Schickel and listed in the National Register of Historic Places in 2007; the Dominican Village, a residential retirement community; Our Lady of Consolation Home for the Aged (pictured here), now located in West Islip; and Sophia Garden, a community-supported agricultural center established in 1995, whose name refers to "wisdom" in the Old Testament.

Ten

GRACIOUS LIVING

HISTORIC HOMES
AND NOTABLE STREETS

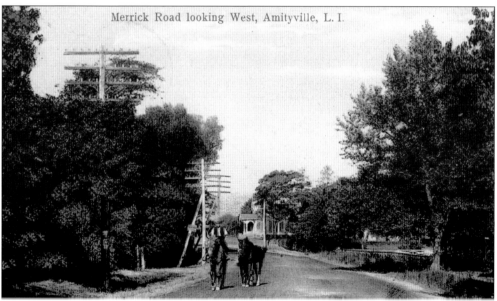

Merrick Road looking West, Amityville, L. I.

Known alternatively as South Country Road, King's Highway, Main Street, and the Merrick Road, today's Merrick Road (also known as Montauk Highway) was always a popular east-west thoroughfare. Until 1859, two tollgates separated Amityville from its western neighbor, Massapequa. In 1895, the year of the great diphtheria epidemic, a rope was tied across this road at the village's western border to prevent outsiders from introducing more of the dreaded disease into the village.

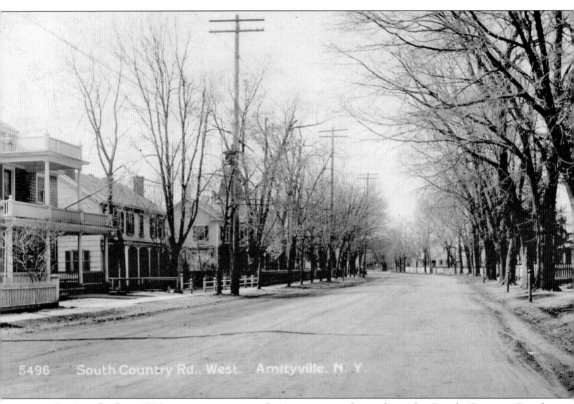

5496 South Country Rd., West Amityville. N. Y.

During the late 1800s, many prosperous businesses were located on the South Country Road. These included the offices of New York state assemblyman Col. Richard J. Cornelius; notary public Joshua Heartt; architect and commission merchant for the Washington market Louis Inglee; the medical practice of Dr. E. Forest Preston; butcher E. K. Terry; and John E. Ireland's sawmill and gristmill. Homan and Davis, near Broadway, was a popular general store.

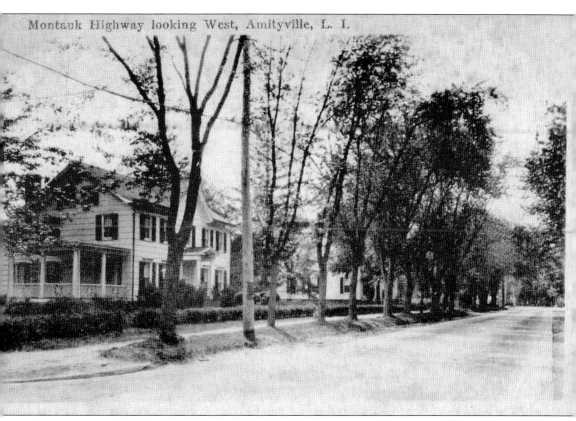
Montauk Highway looking West, Amityville, L. I.

This postcard, titled "Montauk Highway Looking West," depicts the formidable Ireland family homestead built by Samuel Ireland in 1840. This Greek Revival house was originally located on South Country Road, just west of Ocean Avenue across from the family's gristmill. During the late 1950s, it was moved to the southeast corner of what was once Ireland's Pond, now known as Avon Lake.

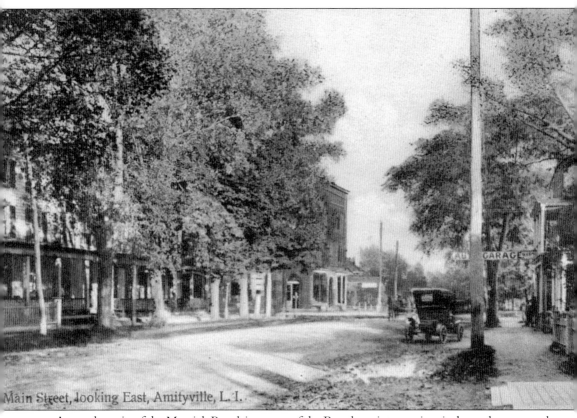

Main Street, looking East, Amityville, L. I.

A popular strip of the Merrick Road, just west of the Broadway intersection, is shown here around 1898. In this view looking east along the north side of the street, several offices and residences are followed by the New Amity Inn in the Elliott Building at the corner. Across the street are the three-story headquarters of the Amityville Club and Eddie Gehrke's Auto Garage.

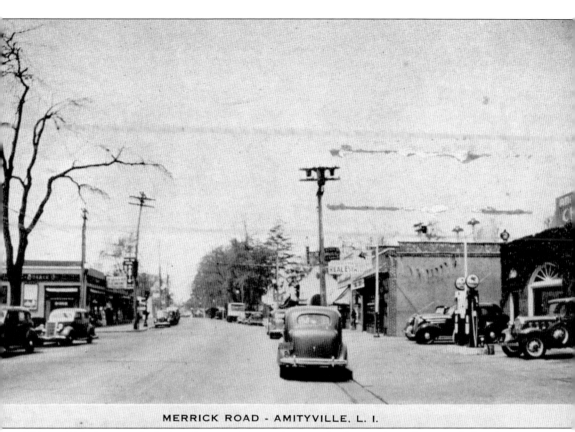

MERRICK ROAD - AMITYVILLE. L. I.

This c. 1936 photograph depicts the same intersection seen in the previous photograph, but from the opposite side, looking west. Shown here at the right are the ivy-covered headquarters of Amityville Chevrolet and the Socony gas station with two gas pumps in front. The real estate office of Judge Charles E. Fisher is visible near the corner of the Broadway intersection. Across the street at the corner of Bennett Place is Bohack's Supermarket.

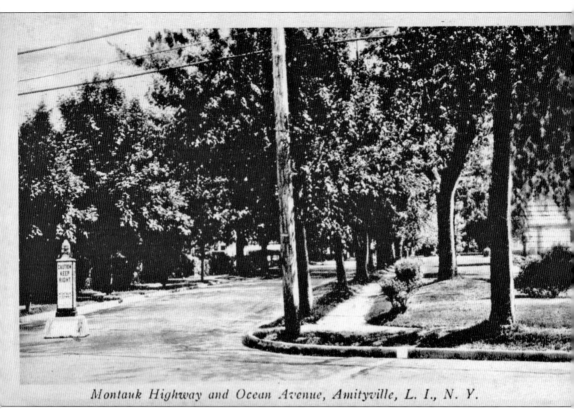

Montauk Highway and Ocean Avenue, Amityville, L. I., N. Y.

Originally a cow path that led to the meadows and later developed during the late 1880s as one of the first wide residential boulevards that led to the water, Ocean Avenue has always been an address held in high regard. As pictured here, an early traffic column that reads, "Caution Keep Right," and features a blinking light was once located at the head of Ocean Avenue at Merrick Road.

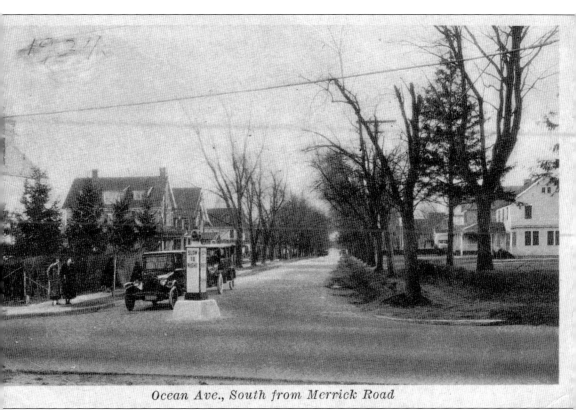

Ocean Ave., South from Merrick Road

The same intersection of Merrick Road at Ocean Avenue is seen here in the 1920s. The lighted traffic column here reads, "Slow to Right." New homes lining either side of Ocean Avenue have been built. Automobiles yield to pedestrians crossing at the southeast corner, which today is occupied by a quiet nautical-themed park. The west side of the intersection today contains a popular strip mall and seafood restaurant.

In this view looking south on Ocean Avenue toward the Great South Bay, the Griffiths' house is seen on the left. Built on the Amityville River around 1894, this twin-peaked, eclectic Victorian was owned by Millard Fillmore Griffiths, a prosperous Manhattan hardware clerk. It was later owned by his grandson, Alfred Wells, a commodore of the Unqua Corinthian Yacht Club. Today, the home is owned and lovingly maintained by the current president of the Amityville Historical Society, Patricia Cahaney, and her husband, Timothy Cahaney.

FOOT OF OCEAN AVE, AMITYVILLE, N.Y.

Located at the foot of Ocean Avenue and Richmond Avenue on the northeast corner is the Mortimer Palmer House. Built on the Amityville River upon the site of the former Ocean Point Hotel in 1907, this grand home provides a classic example of late-Victorian architecture. This photograph was taken from the vantage point of the original Narragansett Inn, which faced this site.

Bennet Place, Amityville, L. I.

This turn-of-the-century postcard depicts two young ladies and a gentleman out for a stroll along Bennett Place, a wide boulevard to the west of Ocean Avenue. The Spanish Mission–style home to their left was owned by H.H. Tinkham, a prominent local personality and owner of the Nassau-Suffolk Lumber Company. The stucco house boasts large square pillars, extended eaves, arched dormer, and a grand foyer.

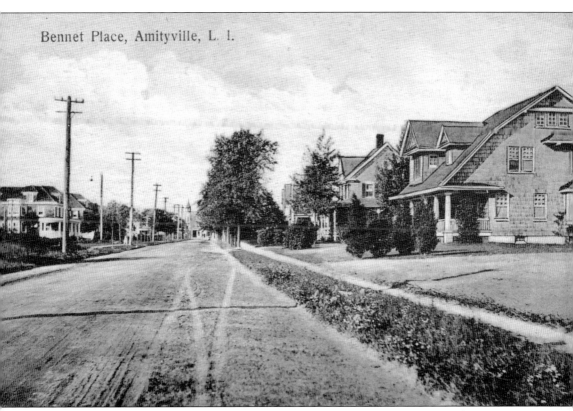

Bennet Place, Amityville, L. I.

Named after landowner Jarvis H. Bennett, whose home was located at the southeast corner of Merrick Road, Bennett Place is seen in this image looking north towards Merrick Road. Married to Phoebe Ireland, a member of another of Amityville's first families, Bennett donated the property to the village in October 1900. Today, this wide boulevard boasts many of Amityville's original homes, including those depicted here. Note the Homan and Van Tassel Building in the distant background.

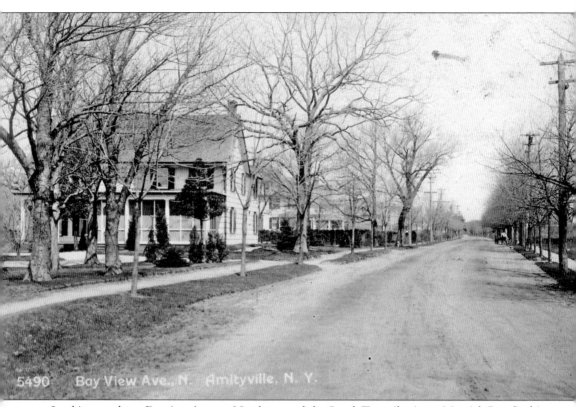

5490 Bay View Ave., N. Amityville. N. Y.

Looking south on Bayview Avenue North, toward the South Turnpike (now Merrick Road), this postcard depicts the J. Edwards home on the left. Bayview was formerly known as Woodlawn Avenue, and this elegant home was located at Oak Street just south of the present Long Island Rail Road tracks. Although little knowledge survives regarding the residents, it is believed by several local historians that the Edwards family may have been acquaintances, if not friends, of George Washington, and in fact, it is quite possible that in 1790, the president may have visited the Edwards family at this location.

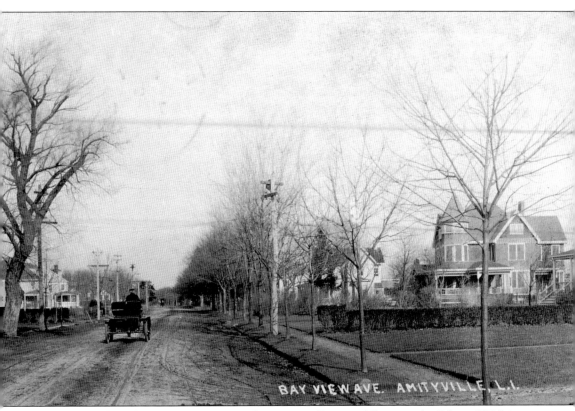

BAY VIEW AVE. AMITYVILLE, L.I.

Traveling northbound on Bayview Avenue, a lone Maxwell automobile passes the Edmund Wallace and Emma Simonson Pearsall home on the right. This imposing Victorian home, set back from the street, boasted a wraparound porch, circular driveway, and porte cochere. In 1968, in honor of her parents, 95-year-old Edna Hawhurst Pearsall, as their only child, deeded this home and the surrounding two acres of property to the Village of Amityville. Before the facility could be opened to the public, the house unfortunately burned to the ground. Today, a bucolic park exists, which includes the garden memorial to Peter J. O'Neill Jr., a young village resident whose life was lost on September 11, 2001.

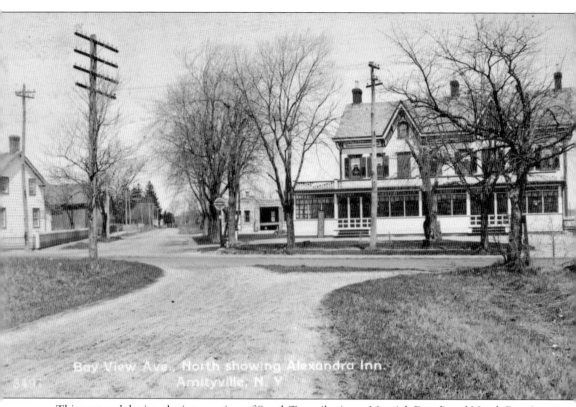

Bay View Ave. North showing Alexandra Inn
Amityville, N.Y.

This postcard depicts the intersection of South Turnpike (now Merrick Road) and North Bayview Avenue. Facing north on the right is the famous Alexandra Inn, later named Shanley's Tavern. Travelling south, Bayview Avenue leads to Amityville Beach. At this busy intersection today, there is a quiet shopping center on the right, and a gas station is on the left.

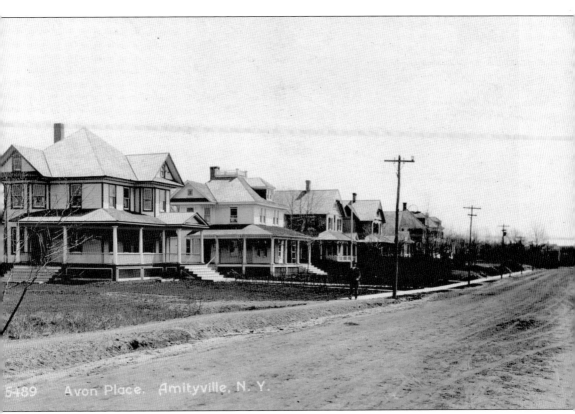

5489 Avon Place. Amityville, N. Y.

This c. 1905 postcard depicts a row of original homes along the north side of Avon Place. This street, which is raised at its center, was named by William Skinner, a civic-minded man and one of Amityville first village trustees. In 1892, Skinner built the road, which led from Broadway to Ireland's Mill Pond, and named it for his adored hometown—Avon, England. The houses shown here still exist today.

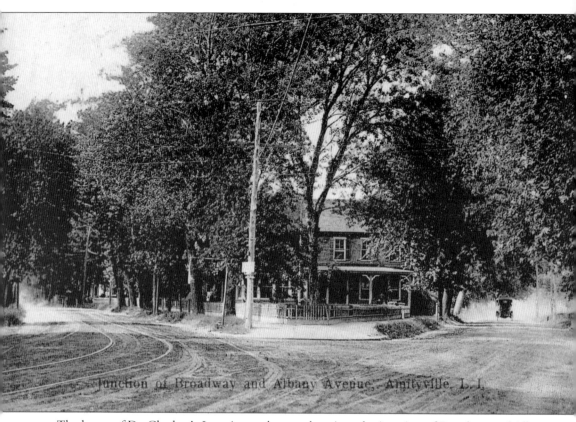

Junction of Broadway and Albany Avenue, Amityville, L. I.

The home of Dr. Charles A. Luce is seen here at the triangular junction of Broadway and Albany Avenue. Luce first came to Amityville in 1891 to fill a post at the Brunswick Hospital. While there, he met his future wife, who was the head nurse at the hospital. After purchasing the Seaman property on Broadway, he established his home and medical practice here. While his private practice grew, Dr. Luce continued to maintain his position at the hospital. As was customary at the time, he made house visits to his patients in a horse and buggy, and later, in a new automobile— a Maxwell. Later, Luce became president of the First National Bank and Trust Company, a position he held until his death in 1943. Adjacent to his property, the pond that existed at the east end of Maple Place, Elm Place, and Mill Street came to be known as Dr. Luce's Pond. During the winter, it was a popular spot for both ice-skating and ice cutting. In due course, the pond was filled in and no longer exists today. Today, a busy gas station occupies this site.

RESIDENCE OF MR. C. DITTMANN AMITYVILLE, LONG ISLAND, N. Y.

The residence of Christian and Bessie Dittman is seen in this undated photograph. Dittman, a mover and private banker, married the former Bessie Rofsett of Brooklyn, New York, in 1908. The couple bore no children. As a result, their lovely brick Georgian Colonial was bequeathed to their neighbor to the south, the First United Methodist Church. Today, the stately residence is home to the Church Attic, a thrift shop run by the United Methodist Women.

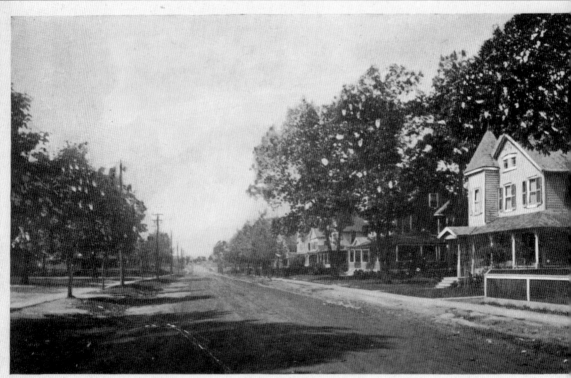

IRELAND PLACE, AMITYVILLE, L. I.

This postcard shows Ireland Place looking west. The houses along the north side of the street sit opposite the Park North Building. Ireland Place, located in central Amityville, borders the Triangle Building. It is named after one of Amityville's founding families. The Irelands owned several local businesses, most notably Ireland's Grist Mill, as well as most of the farmland through which this street and many surrounding ones were carved prior to 1894.

The Lower End of Clocks Boulevard, Amityville, L. I.

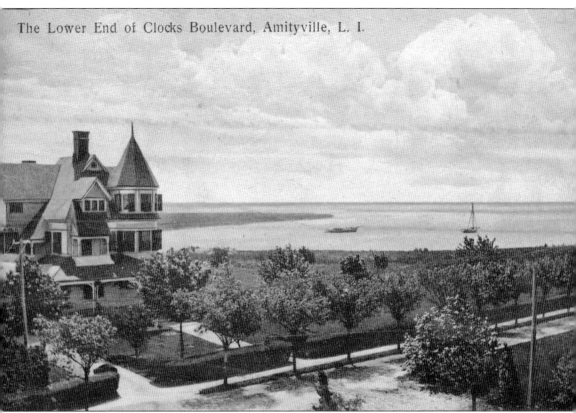

As seen in this photograph, the elegant Victorian home located at the southern end of Clocks Boulevard was considered to be in western Amityville at the time it was built; however, this area is today referred to as Breezy Point in East Massapequa. Located on the east side of the street on Great South Bay, this estate was owned by one of the Clock Brothers, for whom the street is named.

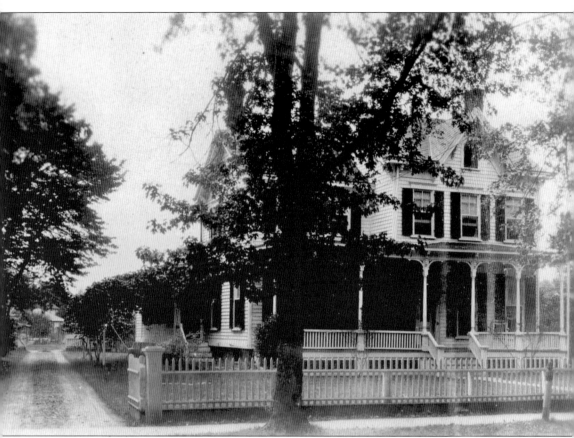

Boasting oak double doors, turned porch posts, and heavy eave corbels, this residence, located at 80 Broadway, has long been known as the Irving Powell House. Named for its original owner, the structure, described by Richard G. Handler in Images of America: *Amityville* as a "vernacular farmhouse with a hint of Victorian detail," was built sometime between 1860 and 1873 by John K. Smith, the grandson of Jesse Smith, who owned the house just to the south at 74 Broadway.

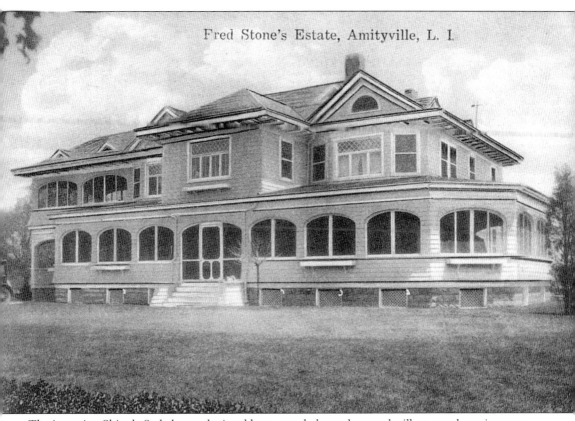

Fred Stone's Estate, Amityville, L. I.

The imposing Shingle Style home depicted here once belonged to vaudeville star and movie actor Fred Stone (1873–1959). Located on Clocks Boulevard along the Narrasketuck Creek in what was once considered West Amityville and is now a part of Massapequa, this sprawling estate was affectionately referred to by Stone as "Chin–Chin Ranch." In those days, it was not unusual to see him with his good friend Will Rogers riding into Amityville astride Stone's fine horses to visit Losi's Corner to purchase choice cigars or tobacco. Along the way, Stone delighted young boys by lassoing them or scooping them up for a short ride and tossing them a few stray coins.

Bibliography

Amityville Historical Society. Images of America: *Amityville*. Charleston, SC: Arcadia Publishing, 2006.

Dibbins, Elodie, Seth Purdy Jr. and Cecil Ruggles, eds. *A Backward Glance*. Amityville, NY: Amityville Historical Society, 1980.

Lauder, William T. *A Brief History of Amityville*. 2nd ed. Amityville, NY: Amityville Historical Society, 1973.

———. *Amityville History Revisited*. Amityville, NY: Amityville Historical Society, 1992.

Lauder, William T. and Charles F. Howlett. *Amityville's 1894 School House*. Amityville, NY: Amityville Historical Society, 1994.

Purdy, Seth Jr. and Elodie Dibbins. *Amityville Remembered: A Pictorial History 1880–1920*. Amityville, NY: Amityville Historical Society, 1986.

ABOUT THE ORGANIZATION

Founded June 14, 1969, the Amityville Historical Society is dedicated to the preservation of the rich historical heritage of Amityville, one of Long Island's charming old communities, and of the surrounding area. The William T. Lauder Museum, established in 1973, is operated by the society as a community, cultural, and educational institution. This museum provides an attractive home where the memorabilia of Amityville's past can be collected, preserved, and exhibited. The museum strives to encourage interest in the preservation of our community's history and to ensure a means whereby future generations can relate to the past.

DISCOVER THOUSANDS OF LOCAL HISTORY BOOKS FEATURING MILLIONS OF VINTAGE IMAGES

Arcadia Publishing, the leading local history publisher in the United States, is committed to making history accessible and meaningful through publishing books that celebrate and preserve the heritage of America's people and places.

Find more books like this at
www.arcadiapublishing.com

Search for your hometown history, your old stomping grounds, and even your favorite sports team.

Consistent with our mission to preserve history on a local level, this book was printed in South Carolina on American-made paper and manufactured entirely in the United States. Products carrying the accredited Forest Stewardship Council (FSC) label are printed on 100 percent FSC-certified paper.

MADE IN THE USA